1000 ISLANDS

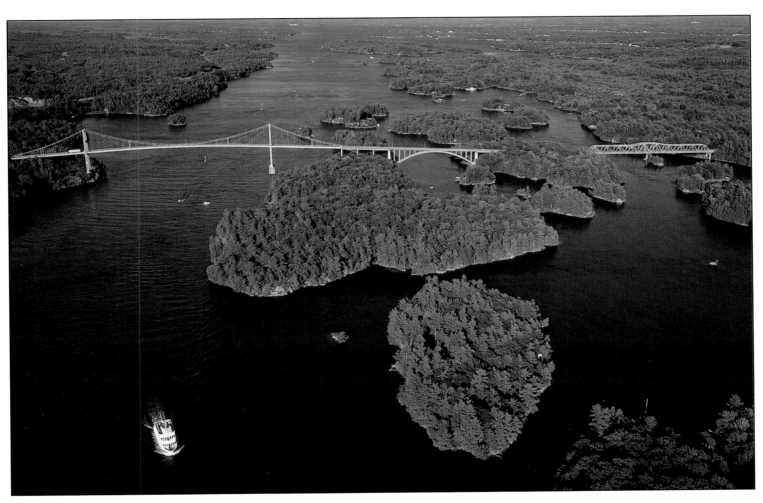

Photographs by John de Visser
Text by Patricia Fleming

THE BOSTON MILLS PRESS

For Dorothy

We gratefully acknowledge the assistance of Patti and David Bain
and their sons Doug and Price. We would also like to thank the many people
who contributed stories and facts toward the creation of this book.

Canadian Cataloguing in Publication Data

De Visser, John, 1930-
 1,000 Islands

ISBN 1-55046-044-7

I. Thousand Islands (N.Y. and Ont.) — Description
and travel — Views. I. Fleming, Patsy. II. Title.

F127.T5D4 1990 917.4'758'0022 C90-093882-X

Design by Gillian Stead
Edited by Noel Hudson
Typography by Justified Type Inc., Guelph, Ontario
Printed by Khai Wah Litho, Singapore

Published by:
THE BOSTON MILLS PRESS
132 Main Street
Erin, Ontario N0B 1T0
(519) 833-2407
FAX (519) 833-2195

Winners of the
Heritage Canada
Communications Award

American Association
for State and Local History
Award Winner

The publisher wishes to acknowledge the financial assistance and encouragement
of The Canada Council, the Ontario Arts Council and the Office of the Secretary
of State.

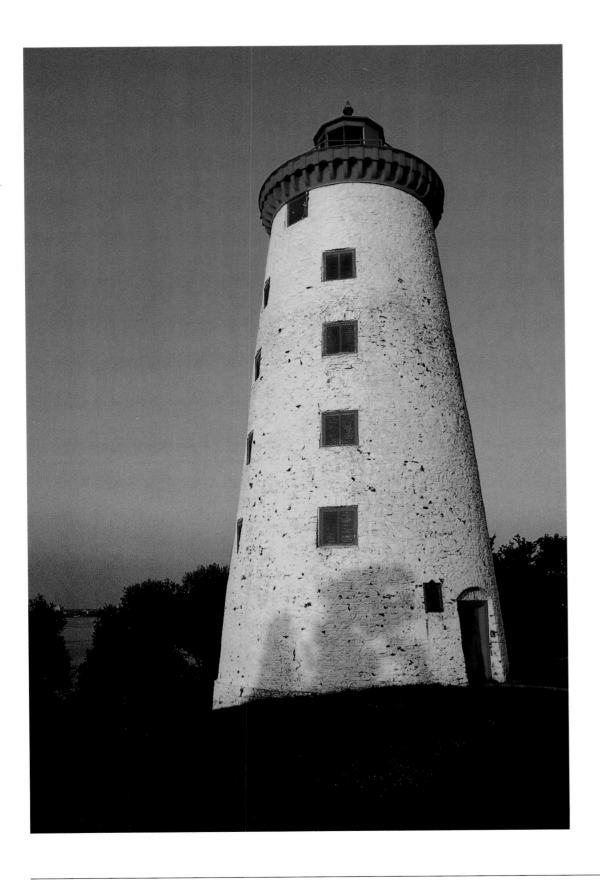

Contents

On the shore of the St. Lawrence River, just east of Prescott, Ontario, stands the famous windmill, built in 1822 and converted into a lighthouse in 1873. It was the site of the Battle of the Windmill in 1838.

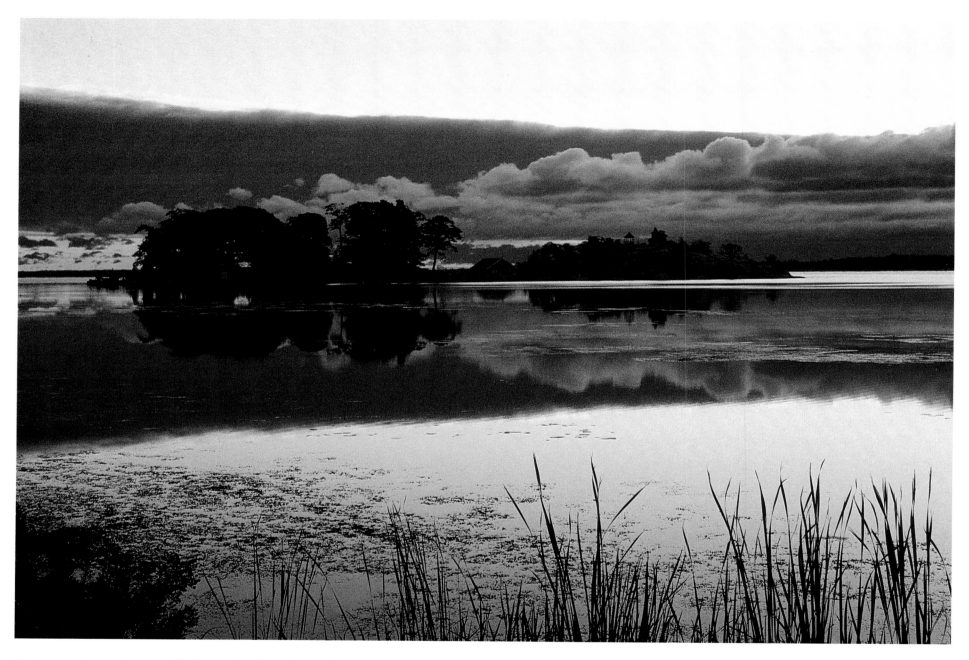

Early morning colour and light on the Canadian side of the St. Lawrence River.

THE 1,000 ISLANDS

The spectacular St. Lawrence River begins at the eastern end of Lake Ontario, where the Great Lakes waters commence their 1,000-mile journey to the Atlantic Ocean. The first 60 miles of this rushing, tumbling waterway cradles the magnificent 1,000 Islands.

The larger islands — Wolfe, Howe, Simcoe and Carleton — divide the St. Lawrence into north and south channels. About 20 miles downriver hundreds of tiny islands cluster around Grindstone, Wellesley, Hill and Grenadier. Near Brockville, Ontario, and Morristown, New York, the river abruptly narrows and its waters leave the 1,000 Islands behind.

On maps, the international border between American and Canadian territory is carefully drawn down the middle of the St. Lawrence, edging around or slicing through the myriad islands in its path. But despite what the line may indicate, the landscape acknowledges no such boundaries.

For 300 years the people who have lived on these islands and on the banks of the St. Lawrence have been part of a turbulent history. The river provided access to the heartland of the continent. It brought exploration, adventure and commerce. And it continues to play an integral role in the history, the heritage, and the formation of the independent national characters of Canada and the United States.

Many of the voyageurs, soldiers and settlers of the 1,000 Islands described this area in their diaries and journals. In 1615 French explorer Samuel de Champlain wrote, "The whole country is very beautiful and attractive. Along the river bank it seemed as if the trees had been planted there for pleasure."

In 1792 Elizabeth Simcoe, the wife of John Graves Simcoe, the first Governor of Upper Canada, wrote, "After passing Grenadier Island we came to the 1,000 Islands. The different sizes and shapes of these innumerable isles have a very pretty appearance. Some of them are miles in extent. . . . The Canadians rowed our boat and according to their custom ceased not to sing. One of them sings a song which the rest of them repeat, and all row in time. The songs are gay and merry and frequently somewhat more. They are only interrupted by the laughter they occasion. The Canadians on all their tours on the water no sooner take hold of the oars than they begin to sing, from which they never cease until they lay down the oars again."

To the Indians, this was the "Garden of the Great Spirit": a place to refresh for winter; a place to plant corn, to find meat and fish; a place easy to come to by water; a place to rest and be at peace.

Although the area is called the 1,000 Islands, the actual count varies from 1,687 to 1,800. Because water levels on the St. Lawrence fluctuate from season to season and from year to year, some shoals and rocks considered to be small islands may occasionally disappear from view.

The area is part of the ancient Canadian Shield, and most of the 1,000 Islands are primarily granite, the oldest being the pink granite, heaved up from deep in the earth many hundreds of millions of years ago. The youngest rock formations are the grey limestone layers, themselves laid down some 450 million years ago. The 1,000 Islands began to be formed only a million years ago. Then came four ice ages. Twelve thousand years ago, as the ice began to melt, the granite mountains were flooded. The water of the Great Lakes, seeking a path to the ocean, worked its way around the

The Axeman Regatta is a 1,000 Island tradition.

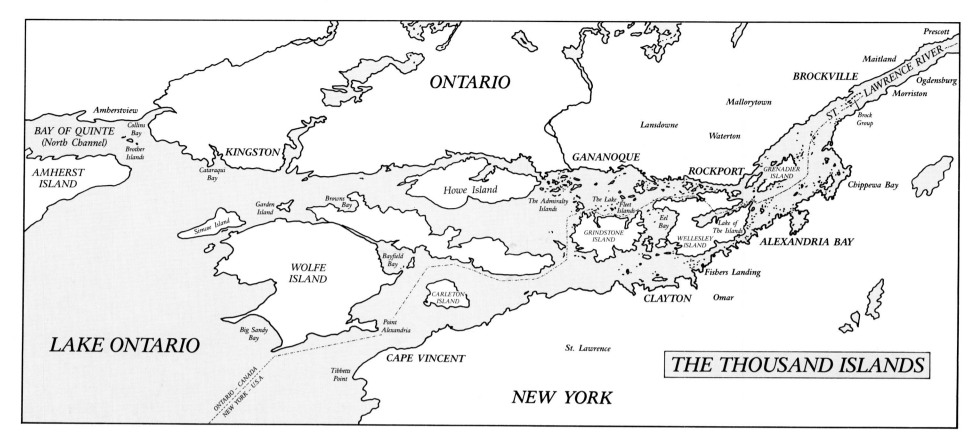

mountains, rolled against their sides, surged over ridges of rock, and as the terrific waters subsided, the St. Lawrence River and the 1,000 Islands were formed.

About half of the islands are on the Canadian side. These were originally owned by the Mississauga Indians, then by the Crown, and in 1870 came under the jurisdiction of the Department of Indian Affairs. Government surveys were taken to establish which islands were needed for lighthouses and other navigational aids. Some islands were designated as parkland. Others were put on the market and sold. At one point, islands under one-half acre were sold for $50, and those five acres or more went for $1,000.

These bargain prices did not exactly start a land grab. By 1891 only 58 of the large islands had been sold. Of the smaller ones, 833 were still available. Many of the smaller islands were used by mainlanders as extensions of their farms. Here farmers grew crops and raised livestock, and the islands were thus named Corn Island, Turnip Island, Potato Island, Blueberry Island, Hog Island, Sheep Island, and White Calf Island.

In 1825 Captain William Fitzwilliam Owen of the British

Royal Navy was assigned to chart the St. Lawrence and to name some of the islands on the Canadian side. Generally speaking, these islands fall into groups or chains. East of Howe Island, near Gananoque, Owen named the first group the Admiralty Islands, commemorating the First Lords of the Admiralty. These include Yorke Island (now Bostwick), Lindsey Island, and Melville Island. Near the north side of Grindstone are the Lake Fleet Islands, named for British warships on the Great Lakes: Bloodletter, Deathdealer, Dumfounder, Scorpion, Astounder, Belabourer, Psyche, Camelot and Endymion. Close to Ivy Lea Village, near the International Bridge, are the Navy Islands, named for naval officers Mulcaster, Hickey, Cunliffe and Downie.

Today there are cottages on most of the islands. These cottages range from tiny seasonal cabins to sprawling year-round family homes with vast manicured lawns. But regardless of land holdings or social class, all of the people who make up the 1,000 Islands community possess a lifetime attachment to these islands and their river.

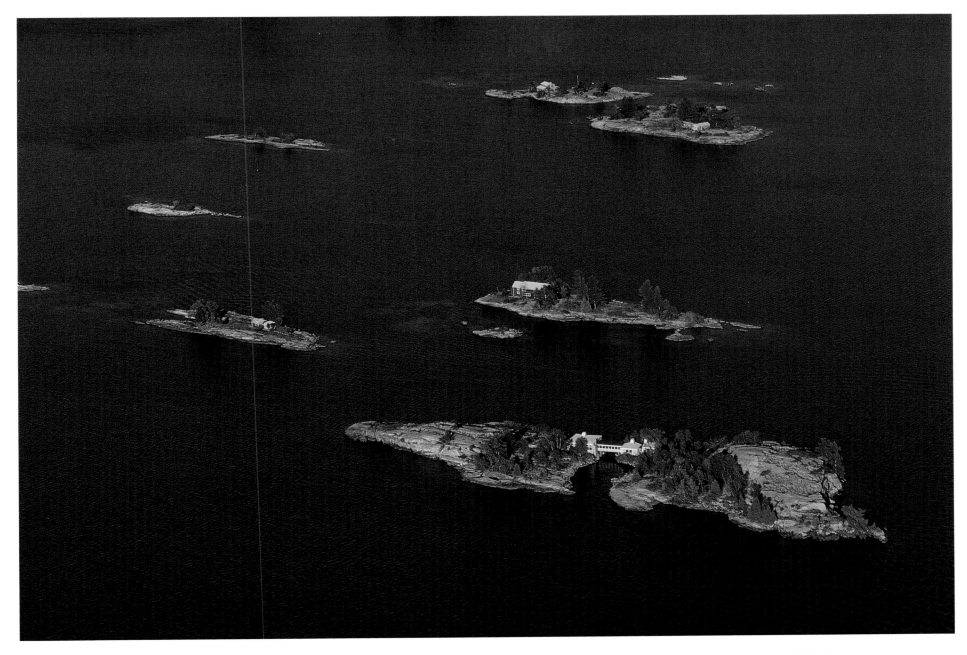

Islands with cottages in Chippewa Bay, New York. The summer home in the foreground straddles the channel between the two islands.

The eastern Howe Island ferry connects Bishop's Point on the mainland with Gillespie's Point on the island.

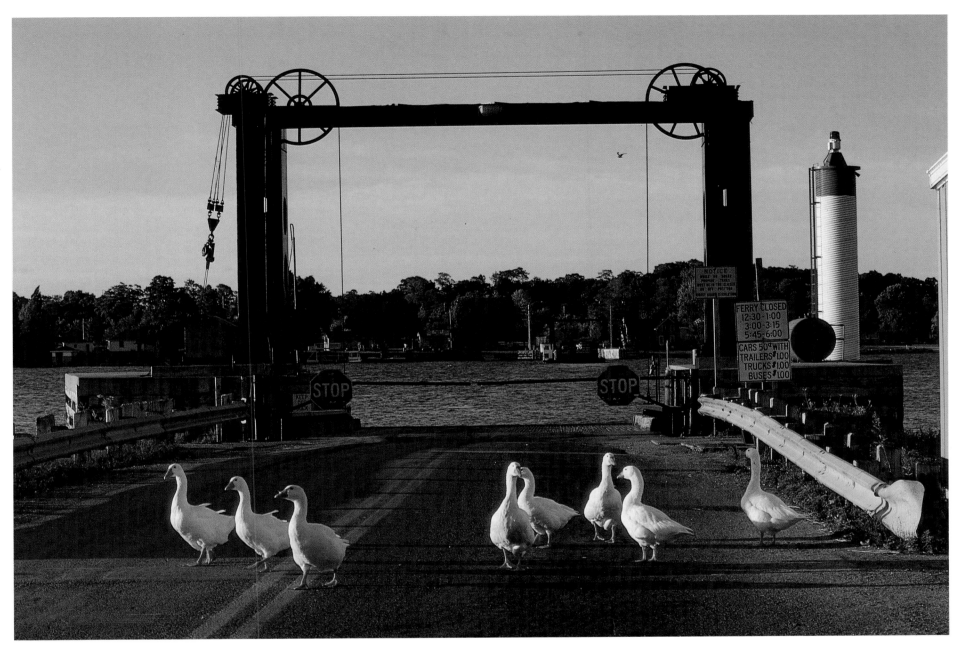

At Pitts Ferry, the main crossing to Howe Island, a gaggle of geese from a neighbouring farm forms an early morning welcoming committee.

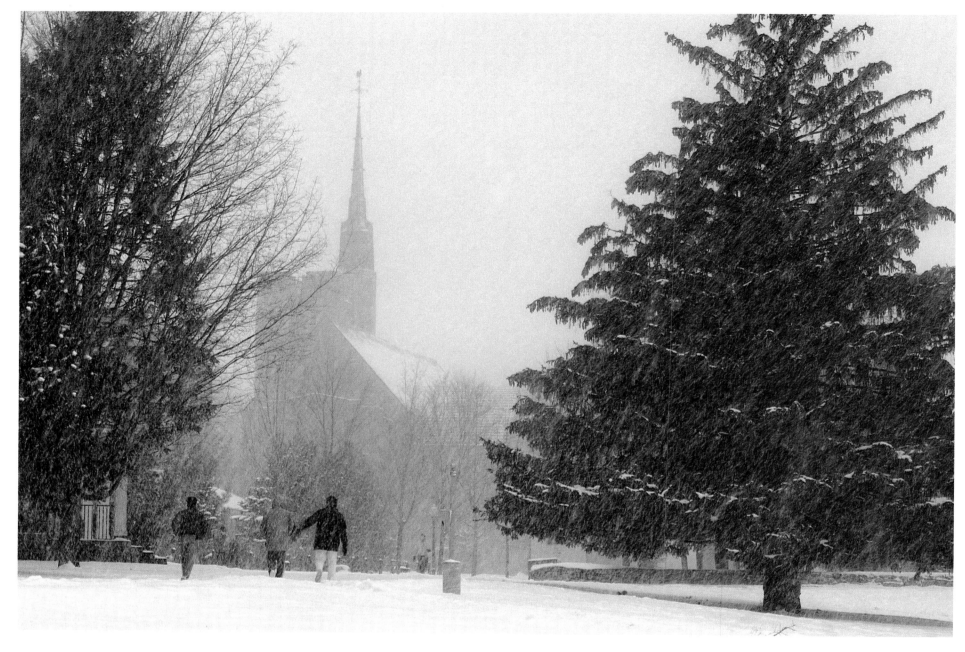

St. Lawrence University at Canton, New York, just south of Ogdensburg, is an independent, non-denominational liberal arts and sciences university with an enrolment of approximately 2,100 students.

The Bonnie Castle Stables, between Alexandria Bay and the 1,000 Islands Bridge, are a year-round entertainment complex which feature rodeos, music concerts, and pony and sleigh rides.

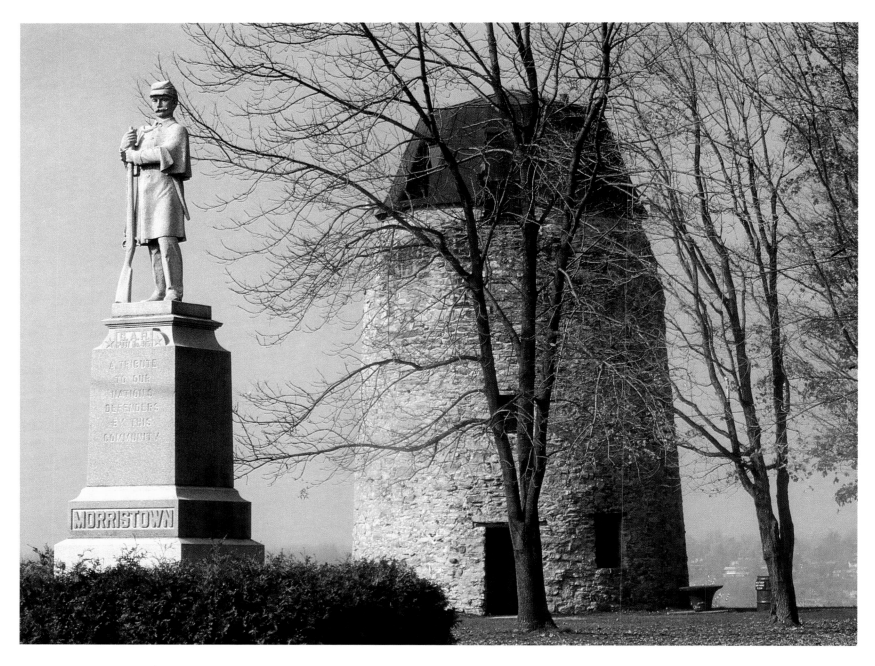

Morristown, New York, was first mapped in 1799 as Morrisville, then established as a town in 1821. The mill was built in 1825 by a Scottish miller, Hugh McConnell. It has also served as the town jail and as an Air Warning Post during WW II. The monument commemorates the 185 men and women of the town who served their country and the eight who gave their lives.

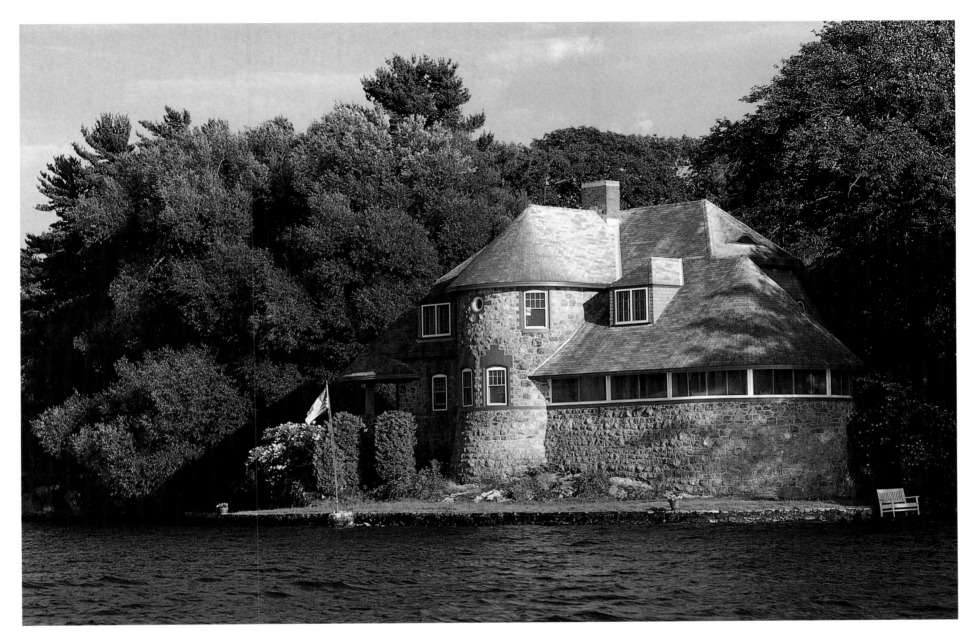

A massive, fortress-like summer house on the U.S. side of the river.

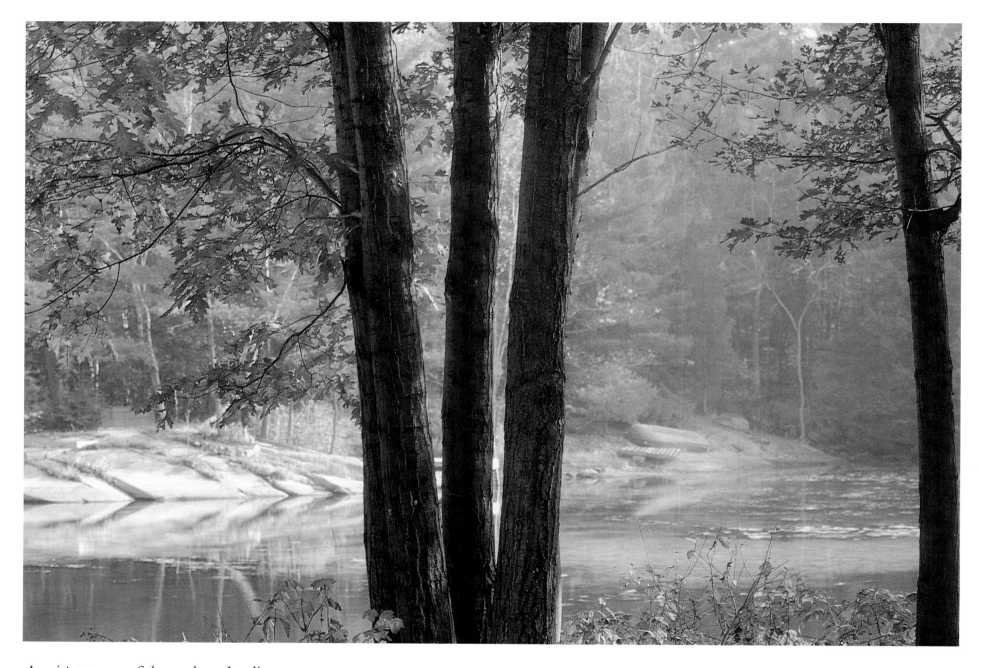

A quiet cove near Schermerhorn Landing.

NATURAL SURROUNDINGS

It seems most typical that where an island is hit by prevailing southwesterly winds, pine trees thrive. Some are bent and stunted, others rise straight and tall. Pitch pines are usually found close to the shoreline; white pine, hemlock, basswood and hickory are generally found further inland. It is not unusual to see the big roots of pines winding down over steep granite cliffsides, reaching for the water.

In earlier years some of the islands were nearly stripped of their timber, which was used to fuel steamboats and as building material for the burgeoning cottages. Today second- and third-growth trees are well established. One river resident recounts, "Over the years we have planted hundreds of trees — white pine, Scotch pine, pitch pine, spruce and hemlock. We also plant a hundred narcissus and daffodils a year to add to the trillium show. A botanist compiled an inventory of all the plant life, from the largest trees to the smallest pond weed. He found a huge range of over 340 different plants, not counting the mosses and lichens."

It would be almost impossible to describe all the life in the 1,000 Islands. If you look around, you will see the marshes, the lichen-covered granite, the trees. If you listen, you will hear the gurgle of the river and the chirp of early morning birds. You will rarely see the snakes and turtles, the fish and wild mammals, but they are here in abundance.

In spring the islands are alive with migrating birds. Those that stay — wrens, kingfishers, finches, orioles and others — fill the crisp morning air with song long before the pesky motorboats begin rumbling about their business. Of the larger birds, the pileated woodpeckers are favourites. We once saw three together, their red-crested heads hammering away at an old tree. In the winter a few bald eagles still hunt for food — fish or the occasional duck — where the swift currents of the St. Lawrence make open water.

But our most favourite bird is the great blue heron. There are lots of them in the islands, and they seem to be birds of habit. At about the same time every evening they fly upriver, some 30 feet above the water, past our cottage. Their huge wings push the air in a steady beat, about the same speed as a five-horsepower outboard (we have timed them). Their skinny heron youngsters land on our deck and have a good look around, then return to an empty island nearby to roost in the trees. The river's trademark could be a great blue heron standing immobile at the edge of the water, waiting for fish.

"Every day I think how lucky we are to live here," relates a fellow 1,000 Islander. "Thirty years ago we bought this property, which had once been a farm. The St. Lawrence Parkway, built in 1939, had swallowed up some of the farm's fields. What was left was a mixture of rocky outcroppings, fields of heavy clay, marsh-edged streams winding down to the river, and stands of oak, pine and hickory with cattle paths wandering among them.

Early morning on the Canadian side of the St. Lawrence.

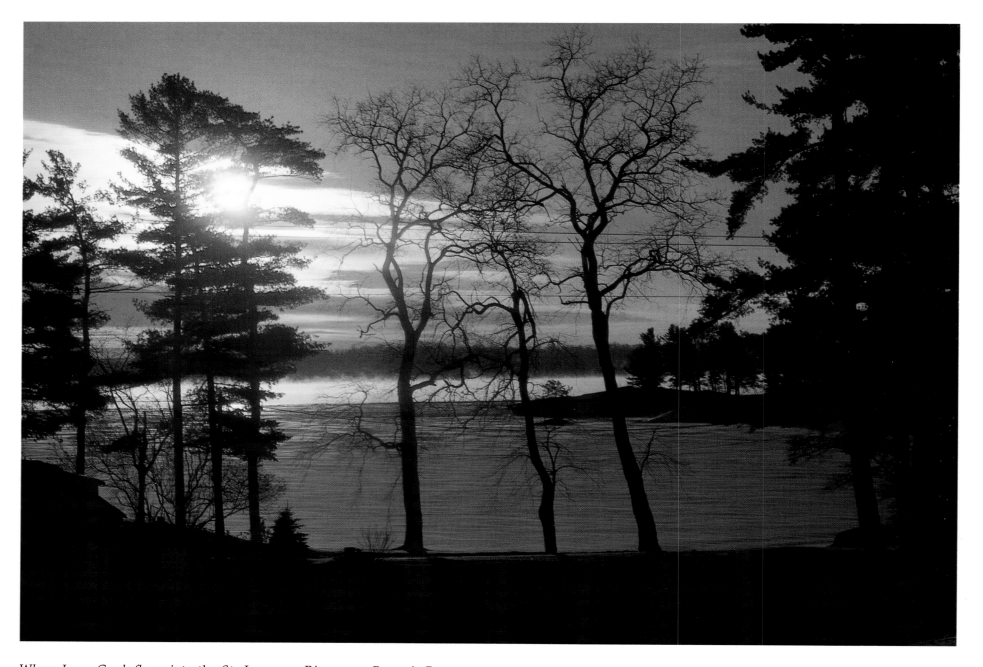

Where Jones Creek flows into the St. Lawrence River near Brown's Bay.

"In the winter neighbours of all ages come to play hockey on a frozen patch of swamp, and our children learned to ski on a hill behind it. They are grown up now, but they still come back, either alone or with friends, just to recharge their batteries.

"In the city, man-made things distract you from the sky and the changing seasons. Here, every detail is noticed and dates noted down: 'crows calling'. . .'frogs singing in the swamp'. . .'hepatica in bloom'. . .'pink velvet leaves open on oak trees'. . .'yellow warblers nesting in the honeysuckle again.' I love to go out in the morning and take a breath of fresh air and hear the birds. We are very lucky indeed."

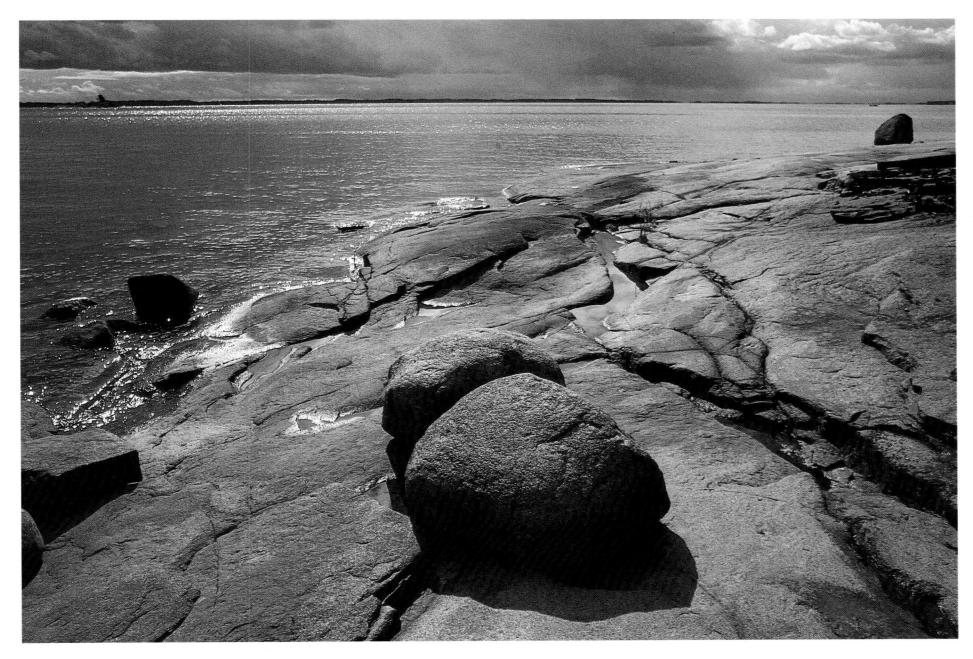

The 1,000 Islands were created by the glaciers of the last ice age. The area's glacially-scraped rock forms some of the southernmost outcroppings of the Canadian Shield, the ancient geologic nucleus of North America.

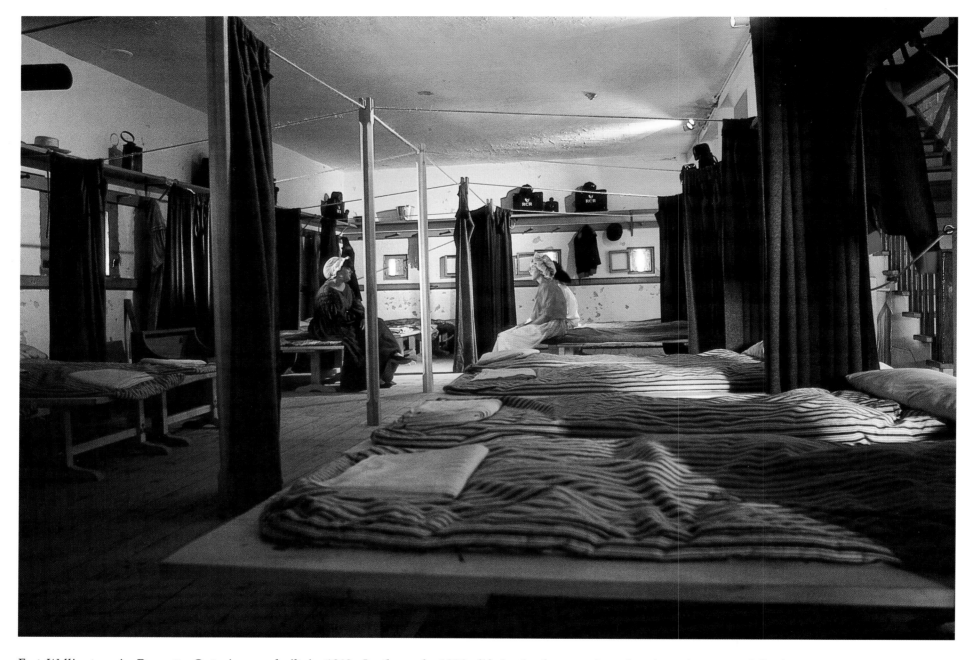

Fort Wellington, in Prescott, Ontario, was built in 1812. In the early 1800s life in the fort was less than luxurious, especially for the ordinary soldier. Here, in the Married Quarters, each family's space was defined by black curtains.

SETTLING THE 1,000 ISLANDS AREA

The banks of the St. Lawrence River and its islands were not the easiest places for the early settlers to clear land for their pioneer farms. The shores were rocky, with only pockets of good farmland. The earliest settlers established landings and hospitable houses in which to shelter river travellers en route to Montreal or Kingston.

After the American War of Independence, settlement patterns changed drastically. Seven thousand Loyalist refugees trekked north to Montreal from the New England states and New York, via the Richelieu River and Lake Champlain, to claim land grants in exchange for their loyalty. Another 3,000 made their way west through the Mohawk Valley and crossed the river to Kingston or continued to Niagara.

The displaced Loyalists were collecting by the hundreds, and Governor Frederick Haldiman had the urgent problem of arranging land grants as soon as possible. Surveyors were sent along the St. Lawrence to establish lots, concessions and townships from Cornwall to Brockville and from Kingston to the Bay of Quinte. Along the river between Kingston and Brockville, the land was broken by outcroppings of granite, and a system of "broken fronts" was developed. Even today the townships are called the "Front of Yonge" or the "Front of Leeds and Lansdowne."

By 1783 the first of the United Empire Loyalists were taking up their lands. Priority was given to local regiments such as the King's Royal Regiment of New York, the King's Rangers (Jessop's Rangers and Roger's Rangers), Sir John Johnson's Corps, the troops under Captain Michael Grass,

and select other English immigrants who decided to remain loyal to the Crown. The settlers were given an axe for every man over the age of 14, materials for building a house, clothing, a cow, and enough seed for two years' crops. With that, the frontiersmen-farmers set to work hacking their homes out of the forests along the St. Lawrence.

By 1812 Frontenac, Leeds and Grenville, the three river counties bordering the 1,000 Islands, had been allotted. Gananoque had four houses and a mill. Buells Bay (Brockville) had a landing and 26 buildings. Kingston had 150 houses and 1,000 people. In total, 10,000 Loyalists had settled by that date.

On the American shore, there was no immediate rush by pioneer settlers to the remote forests and cold climate of northern New York State. There were much more attractive farmlands further south. Those Americans who did choose to live here were mainly lumbermen who bought their land from the Oneida Indians. To these lumbermen the St. Lawrence was the highway on which to transport timber to Montreal. The American economy was linked by the river to the Canadian economy.

One of the most famous and honoured Loyalists who settled in Canada after the War of Independence was Molly Brant, wife of Sir William Johnson. With her brother, powerful Mohawk chief Joseph Brant, she helped maintain the Mohawk tribe's loyalty to the Crown for over a half a century.

An Englishwoman once described Molly Brant this way: "Her features are fine and beautiful. Her complexion clear and olive-tinted. She is quiet in demeanour and possessed

An old-style log cabin near Kerry Road in the 1,000 Islands.

An 1840s Italianate-style villa on Centre Street in Kingston, Bellevue House was the 1848-49 home of Sir John A. MacDonald, Canada's first Prime Minister.

of a calm that bespeaks native pride and conciousness of power. She seldom imposes herself into the picture but no one is in her presence without being aware of her."

Molly's father had been received by Queen Anne at St. James Court in 1710. Her people lived in the Mohawk Valley, as did Sir William Johnson, the Superintendent of Indian Affairs, who owned 130,000 acres of land. Molly Brant and Johnson had many children, eight of whom lived to adulthood. In her own right she was matriarch of her tribe and chose to be known by her own name, though officially Molly Brant was Lady Johnson.

Sir William died in 1774. The following year Molly passed intelligence to the British armies north of the border. Because of her strong Loyalist commitment she was eventually compelled to leave New York, so she gathered her family and made her way north to Fort Haldiman on Carlton Island, just south of Wolfe Island, across from Kingston. In appreciation of Molly's loyalty and her tremendous influence among the Mohawk, Governor Haldiman sent directions that she should have an annual pension and a house built for her near the entrance to Fort Frontenac, as well as one for her brother, Chief Joseph Brant.

In 1783, after four years on Carlton Island, Molly moved to Kingston. She and her daughters were greatly respected in the small community. She was a devoted Anglican and helped found the first St. George's Church. Molly Brant died in 1796, at a time when Kingston was expanding into a merchant and shipbuilding town. She is buried in the churchyard of St. Paul's Church on Queen Street.

An old barn along Highway 2 east of Kingston.

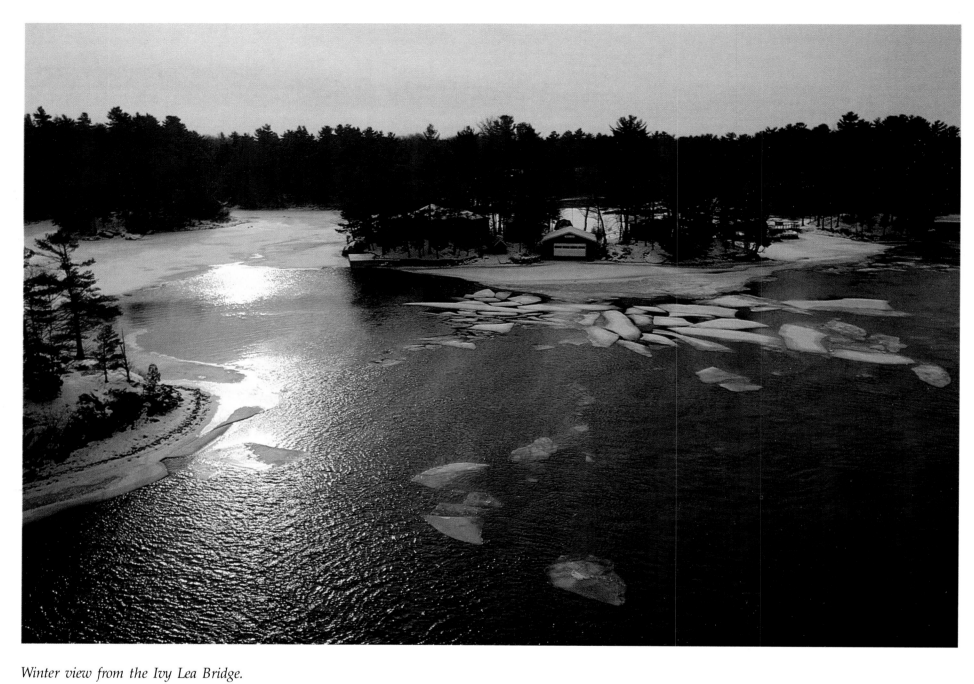

Winter view from the Ivy Lea Bridge.

TIMBER-RAFTING IN THE EARLY 1800s

In the early 1800s huge half-mile-long rafts of timber (the distance between 25 telephone poles on the highway) made their way down the St. Lawrence, weaving among the islands, delivering oak and pine to the timber coves of Quebec City.

Britain needed wood for building construction and for her navy's ships. The wars in Europe had cut off that supply of lumber, and Canada was ready and eager to fill the gap. In 1810, 661 ships cleared Quebec City bound for England, carrying 33,798 tons of oak and 69,271 tons of pine.

Our cottage happens to be on an island near Raft Narrows. Here the North Channel narrows, the river deepens, and the mighty St. Lawrence picks up speed as it flows beneath the International Bridge. It picks up in power and pace on its way to the sea. This relentless flow served the lumber industry in the 1800s as it had the fur barons of the 1700s.

Around 1832, when my great-grandfather was about 18, he travelled to Quebec City with the rafts, then rowed as an oarsman in a bateau back to Kingston, only to turn around and immediately take another raft down the river. Perhaps he sometimes greeted the day, and the current, at our island, just as we do today.

At the entrance to the St. Lawrence, hard by Wolfe Island and just off Kingston, lies Garden Island, a small island with a moon-shaped southeast bay. Today the island is a summer-cottage community, but some of the families who come here are descendants of the 700 people who lived here when Garden Island was the timber-rafting and shipbuilding capital of Canada. It was here that lumber was collected from the forests bordering the Great Lakes. The oak and pine logs were unloaded into the southeast bay, then built into rafts to be propelled downriver by the current alone.

These rafts were formed by "drams" or "cribs." A crib, about 60 by 42 feet, was the floating framework for the timber. It was held together, not with bolts or nails, but by withes, tree branches which had been crushed to make them as pliable as rope. Four or five cribs were lashed together into a dram, extending the raft to a total length of 250 to 300 feet. A dozen or so drams made up the complete raft. When a raft passed through rapids, it was broken into its individual drams. These rafts had sleeping shanties for the raftsmen, a cookhouse, and the bateaux for the return journey to Garden Island.

Many of the raftsmen's friends and relatives considered the trip an enjoyable one, a welcome adventure, and they would join the raft for the 350-mile trek to Quebec City.

And if, en route, a dram or crib fell apart in a storm, doubtless the timbers eventually became the docks and homes of the 1,000 Islands.

Freighter passing Sister Island.

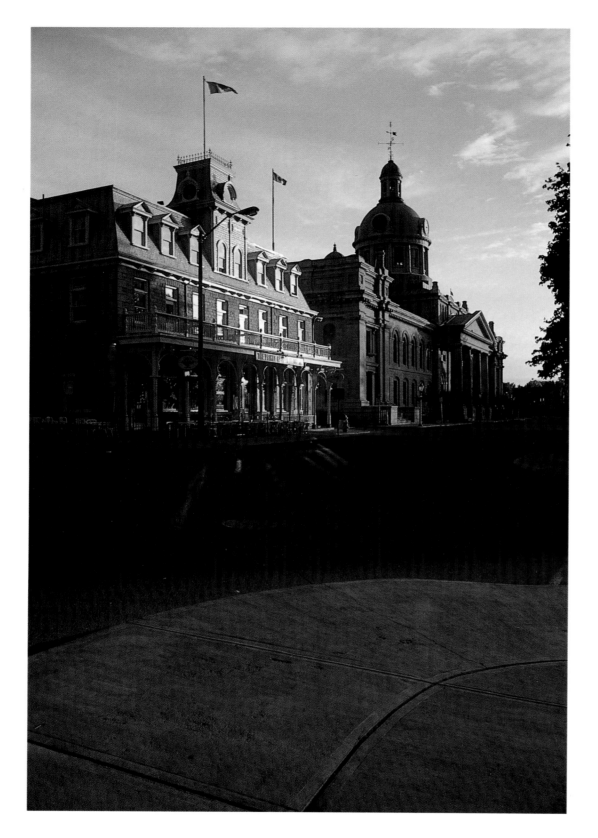

Construction of Kingston City Hall was begun in 1842, while the city was the capital of the Province of Canada. Designed by architect George Browne, the building is constructed of local limestone in Neo-Classical style. The Prince George Hotel next door provides a fine complement to the City Hall.

THE BUILDING OF KINGSTON

The grand City Hall dominates downtown Kingston. Its front facade, with its enormous pillars, faces east across Kingston Harbour toward the Royal Military College and Fort Henry, and southeast to the opening of the St. Lawrence, where it flows around Wolfe Island. The clock-tower bell rings out the time, and the north-side market is crammed with farmers' stalls and alive with people three days a week—and so it has been for many years. From the steps on the harbour side of City Hall, dignitaries are welcomed, citizens thanked, and it is from here that soldiers have been sent off to war, including companies of the Royal Canadian Horse Artillery and the Princess of Wales' Own Regiment. It is also at this location that the high jinks of Winterfest take place and where the summer street dances last late into the night.

From 1841 to 1844 Kingston was the capital of Canada. In high hopes of a prominent and prosperous future, grand public buildings worthy of a great city were planned and built. The City Hall, the Courthouse, and much of the Kingston core were constructed to accommodate 3,000 new residents and the government of Canada. Substantial limestone houses line the main street.

The man responsible for Kingston City Hall was George Browne, a 31-year-old government-building architect who won a competition for his design. The total cost of the building was £20,000, £10,000 over his original estimate, but no one complained. It was, in the words of one military officer of the day, "the finest edifice on the continent of America."

There has been a strong military presence on the St. Lawrence near present-day Kingston since the mid-1700s. These early years were uneasy ones along the river, as Canada first struggled to reconcile its English and French settlers into one nation, then warily watched the emergence of a new, aggressively independent neighbour to the south. The European struggle between the French and the English made its way to the 1,000 Islands region in the War of 1812. And in the 1840s the Oregon Controversy, resulting from an American proposal to draw the boundary between Canada and the U.S. along the 54th parallel instead of the 49th, thus placing the St. Lawrence inside American territory, made for renewed tension between the two countries.

It was during the Oregon Controversy that Kingston was made the capital of Canada, and a great construction boom took place. The Rideau Canal system was completed, City Hall was built, and Fort Henry was redesigned and rebuilt to its present plan.

Fort Henry is located high on Barriefield Hill, with a breathtaking view of Lake Ontario, the islands, and the city. In 1989 some 180,000 visitors came to Fort Henry to watch the Evening Retreat and the parades, which recapture a sense of the military pageantry of 150 years ago. At sundown the bugles sound and the guns roar in reminder that this magnificent fort once stood on guard for Canada.

Four Martello towers were also built during Kingston's construction boom: one on Cedar Island at the opening of the St. Lawrence River; one at Fort Frederick; one in Kingston Harbour; and one at Murney Point, slightly west

The Royal Military College at Kingston.

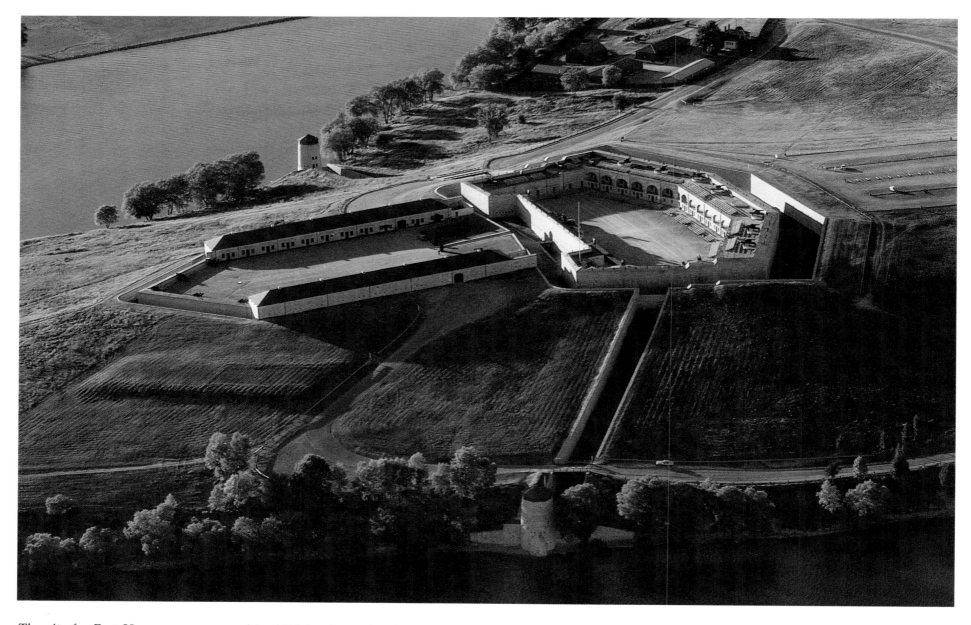

The site for Fort Henry was suggested in 1819 by the Duke of Wellington. It guards the entrance into the St. Lawrence River from Lake Ontario. The fort was built between 1832 and 1848.

of city centre. These rounded limestone turrets with angled protrusions were designed in such a way that cannon balls would be deflected from their rounded sides and they could not be breached. The roofs of these towers were wedge-shaped panels that could be dismantled quickly to allow a 360-degree range of fire. The cannons fired 36-pound balls and each tower was manned by 30 to 40 soldiers.

For many years, when I was young and growing up near Kingston, the 12 o'clock gun was an important part of my family's life. The gun boomed out over the city, signalling the orderly progress of the soldiers' working day, and the dogs barked, and we dropped whatever we were doing and headed home for lunch, lest we receive a domestic court-martial for tardiness.

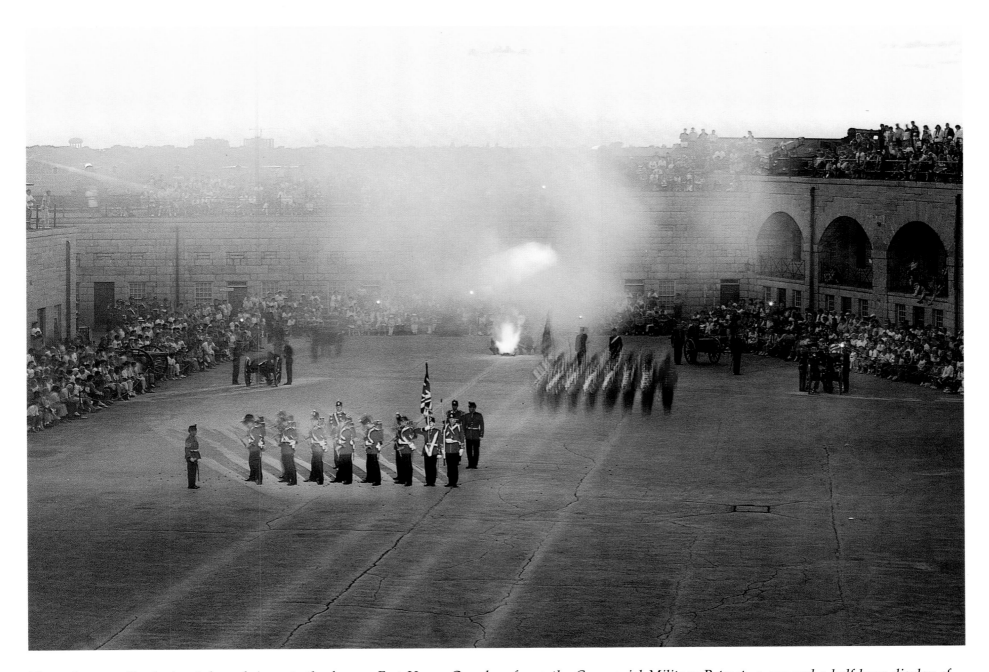

Three times weekly during July and August, the famous Fort Henry Guard performs the Ceremonial Military Retreat, a one-and-a-half-hour display of drills and manoeuvres performed to the exact specifications of the British Army Manual of 1867. The Retreat ends with the lowering of the flag and the firing of the fort's big cannons.

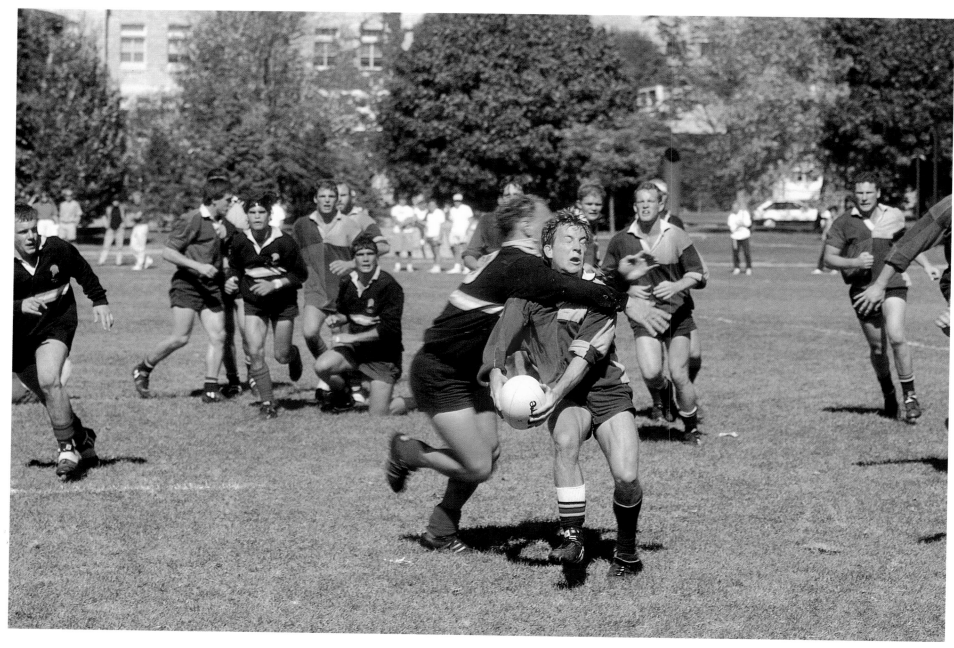

A game of rugby at Queen's University, Kingston.

Queen's was founded in 1841 and received its Royal Charter from Queen Victoria that same year.

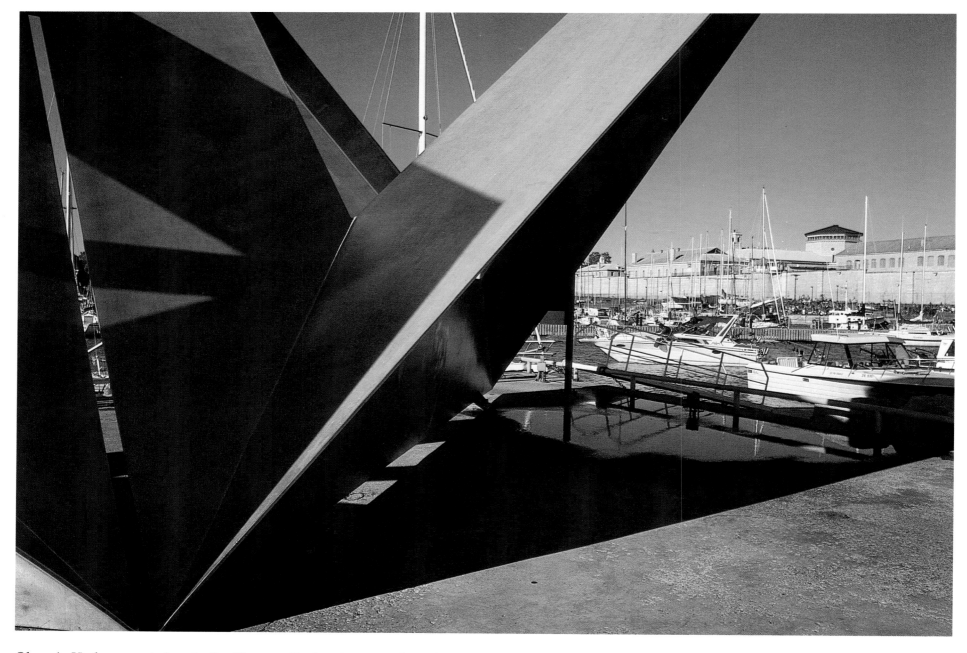

Olympic Harbour, next door to the Kingston Penitentiary, was built for the sailing events of the 1976 Summer Olympic Games. The sculpture is by Ted Bieler.

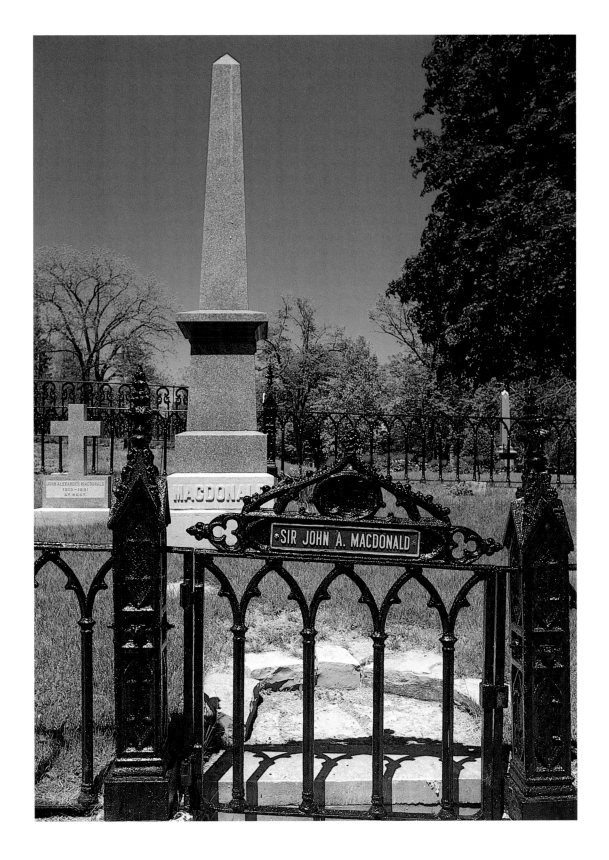

Sir John A. MacDonald (1815-1891) came to Kingston from Scotland with his family at age five. As a lawyer and politician he was instrumental in bringing together the four provinces which in 1867 formed the Dominion of Canada. MacDonald became Canada's first Prime Minister and is known as one of the Fathers of Confederation. His grave is in the Cataraqui cemetery just west of Kingston.

The Wolfe Island ferry leaves the Kingston dock across from the Royal Military College on a wet autumn day.

GUNBOATS ON THE ST. LAWRENCE

In North America the War of 1812 was the war that no one really wanted. Eleven of New York State's 14 state representatives voted against going to war. One third of the U.S. Congress voted against the decision. But the conflicts between the French and the English in Europe reached across the ocean and soon the Americans, on the side of France, were pitted against the Canadians loyal to Britain.

Most of the men living in the river settlements on the Canadian side had until recently been British regular soldiers. They had chosen to remain in Canada and had received land grants from the government. Although stalwart fighters, they too were reluctant participants in the war.

The St. Lawrence River was the essential supply route by which the British reached their forts and defences on the Great Lakes. The Americans, however, could move east or west by more inland routes and were less vulnerable to attack. The major battles of the war took place at Queenston Heights, York and finally at Crysler Farm, but there was a continual war of small skirmishes back and forth across the St. Lawrence and in the 1,000 Islands. Most of the river communities were involved in raids and counter-raids. Prisoners were taken. Ammunition was stolen. Pirates and privateers harassed supply shipments on the river as well as on land. Militia companies were mobilized and readied for action.

In early 1813 American Captain Forsythe was assigned to attack Gananoque in order to capture ammunition. Forsythe's men were met by militia fire, but when the Americans charged, the militia dispersed. The ammunition was successfully captured and the Americans withdrew, leaving behind only one casualty, Mrs. Stone, the wife of the town founder, who had taken a bullet in her hip.

Forsythe then took his men to Ogdensburg, at a narrower part of the river, where he could more easily harass the British. The Canadians attacked across the river, but the attack was repulsed. Thinking he was secure, Forsythe sent his militiamen home for the winter. With his remaining regulars, he set out across the river to Brockville, where he took munitions and prisoners. So far the war on the river was not a great Canadian success. Then the British forces at Prescott retaliated and attacked Ogdensburg. In a brief exchange they took the town, released prisoners, and captured 11 cannon, military stores and ammunition before withdrawing. Soon after, the Americans left Ogdensburg for Sacketts Harbour, and that was the end of military action in the 1,000 Islands region.

The islands were perfect cover for this kind of hit-and-run harassment. The American government gave permission for two non-naval ships to become privateers. These were the *Fox* and the *Neptune*, and in one action they successfully

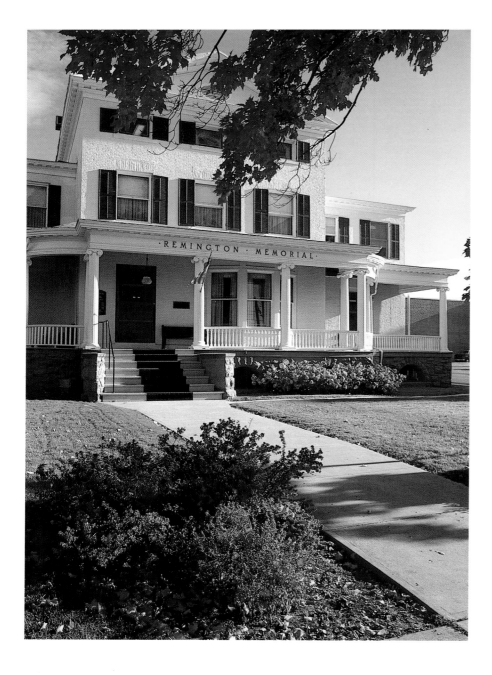

The Frederic Remington Memorial Museum in Ogdensburg, New York, displays some of his famous Wild West bronzes and oils.

captured 64 prisoners, a cannon, and 270 barrels of pork from a British convoy. As soon as the news hit Kingston, three gunboats set out in hot pursuit, down the South Channel to Goose Bay, up Cranberry Creek (east of Alexandria Bay). They landed in the middle of an ambush and after an exchange of fire both sides withdrew.

The gunboats were wide with shallow drafts, very solidly built, with a cannon on the bow, a mast and a sail to assist downwind passage, and since they didn't have centreboards, enough oars and men to power the cumbersome boats across or against the wind. Ranging from 40 to 60 feet in length, these gunboats were designed as escort boats to prevent ambushes and to protect convoys carrying supplies. Many of these naval workhorses were built in the Kingston shipyards.

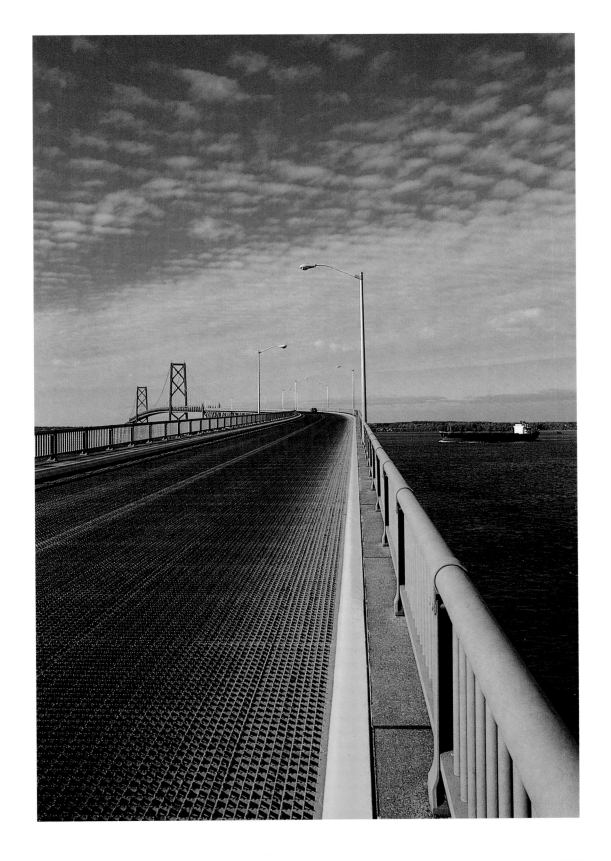

The international bridge at Prescott–Ogdensburg was opened in 1960. The St. Lawrence River widens dramatically at this point.

This house at Cape Vincent may have belonged to the French Count Jacques Donatien Le Ray de Chaumont or to Napoleon's Chief of Police, Count Real, both of whom lived at Cape Vincent circa 1815-1820.

CAPE VINCENT'S FRENCH PAST

In 1787, while the Canadians were busy surveying land for Loyalist settlement on the north shore of the St. Lawrence, on the American side lands were being sectioned into ten potential towns and townships. Loyalist Canadians who received government free land grants settled their new properties quickly, building homes and planting crops. On the American south shore, however, land in the ten townships was sold out of New York City and was bought in huge tracts by speculators, who then resold the land to individuals who could see potential profits in lumbering and in the excellent water transportation route to the markets of Europe. (This buying and selling of land seems familiar today, as we see the farmlands of the St. Lawrence disappearing to modern developers.)

Cape Vincent was one of the ten planned towns, but it has a most unusual origin.

In 1815 a French count named Jacques Donatien Le Ray de Chaumont bought 220,000 acres of land on the south shore of the St. Lawrence. His property extended as far south as Oswego. Le Ray's father — and many other Frenchmen — had supported Lafayette and the American Revolution. After the war he was owed vast sums of money and he sent his son to America to collect the debt. While in New York young Count Le Ray became interested in the remote forests being sold, and he bought his huge acreage.

After Napoleon's defeat in the Napoleonic Wars, several of Le Ray's exiled friends came to visit him in America, including Napoleon's brother, Joseph. In 1815 Joseph Bonaparte bought 26,840 acres at Cape Vincent, where he built two large houses and a hunting lodge. Napoleon's Chief of Police, Count Real, also built a house here. Count Le Ray built his own stone house close to the river. This massive structure, with its small cottage next door, would seem quite at home in the French countryside.

Joseph Bonaparte left the United States in 1833, never to return. But the Frenchmen had left their mark. The towns of Cape Vincent, Alexandria Bay and Teresa were named for Count Le Ray's children. And Cape Vincent holds an annual French Festival to commemorate its unusual past. In the words of one Cape Vincent woman, "We don't celebrate July 4th. We have our French Festival. For two days we close the main street, and we have parades and bands and fireworks."

The other, more modern, entrepreneurial American face of Cape Vincent is displayed near the dock where the ferry to Wolfe Island and Canada lands. Clustered here shoulder to shoulder are Cape Vincent's many fishing lodges, bait shops, boat and fishing equipment establishments, and its fish hatchery. As the large sign says, "Be Ready to Fish."

Near the Wolfe Island ferry, Cape Vincent.

Seen from the Tibbetts Point lighthouse at Cape Vincent, a freighter heads out from the river into the night on Lake Ontario.

During its annual French Festival, Cape Vincent, New York, is decorated with the French red, white and blue.

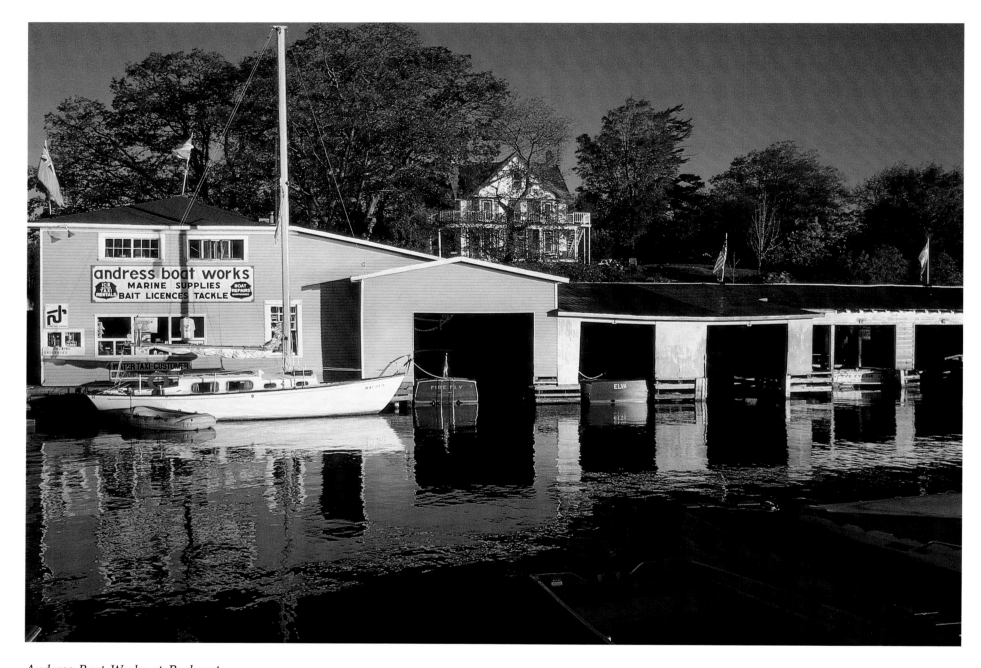

Andress Boat Works at Rockport.

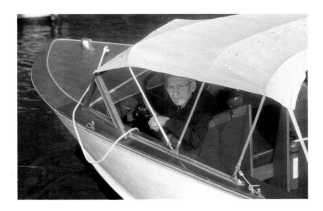

THE ST. LAWRENCE SKIFF

"How would you like to go out fishing in the old skiff?" he asked.

I could hardly believe my ears. A chance to row a St. Lawrence skiff, to cast over those elegant low sides and drift in the current beside the island. A chance to feel the balance, speed and manoeuvrability of one of these famous old river boats.

"I'd love to," I replied.

Nowadays St. Lawrence skiffs are rare indeed. As you putter through the islands you may catch a glimpse of one in a boathouse, a pre-1900 skiff in pristine condition, ready to be exhibited at next year's antique boat show. Or perhaps you will find one tucked up in the rafters of an old barn, a bare hulk of greying wood with no paint or varnish left on it. A few are still kept around, in good working shape, for the occasional pleasure of families who have been using the same boat for generations. In these boats the children have learned to fish, to row, and perhaps to sail — although in rudderless St. Lawrence skiffs, special skills are required.

The St. Lawrence skiff is one of the trademarks of the 1,000 Islands. It is a uniquely designed rowing boat that was first developed around 1840 to meet the needs of rural settlers. The skiff was sturdy, stable, lightweight, and could easily be rowed by one man. It could carry milk and produce, sacks of grain or flour, or transport the family to the nearest village. It could handle the choppy waters kicked up by the prevailing southwest winds. And it was great for fishing.

The standard St. Lawrence skiff is a double-ended, clinker-built rowboat, 18 feet long with a 42-inch beam. It is rowed by seven-and-a-half-foot oars that are held onto the boat by tholepins. It is sharp and high at the ends, with a wide, flat bottom and well-rounded sides. The bottom boards are usually heavy white oak (which provides some ballast) and the side strakes are of cedar or white pine. It has little freeboard, but because of its rounded sides, it rolls easily away from waves and is hard to capsize unless swamped. It is fast, dry and a pleasure to row. For a hundred years the St. Lawrence skiff was both workhorse and pleasure craft to practically every family on every island.

The first skiffs were probably built by some of the United Empire Loyalist settlers who flooded north and inland from the Atlantic coastal towns following the American Revolution. Up until the 1840s the settlers used heavy, square-ended punts. At first the skiffs were built during the winter months by local carpenters, who shared and adapted skiff patterns. In the 1880s and 1890s the skiffs' popularity grew with the increasing number of sports-fishermen who were finding their way to the St. Lawrence in quest of muskellunge, bass and pike. In these pre-small-engine days, the St. Lawrence skiff was the perfect fishing boat. Factories and boatbuilding shops sprang up in Alexandria Bay, Clayton, Brockville, Gananoque and Rockport. You could now order your skiff from many sizes and grades of quality, 14 to 18 feet or larger, designed for one or two rowers, roughly finished or with fine handwork. In 1885, at the height of production at A. Bain & Company of Clayton, 25 skiffs a week were produced in 9 styles, costing from $40 to $150.

In Canada, superb skiffs, with consistently excellent

Elmer Andress at the wheel of Little Elva.

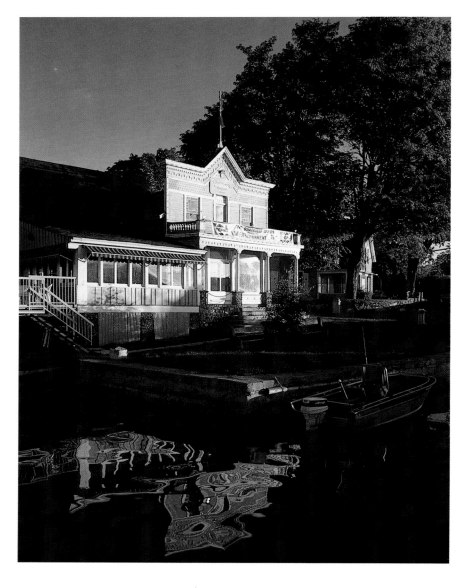

The Boathouse Restaurant at Rockport.

craftsmanship, came from the boathouses of George and Ray Andress in Gananoque and cousin W.E. Andress in Rockport. The Andresses couldn't compete in quantity with the U.S. boat shops, but they could in quality. W.E. Andress, his son, and six carpenters produced 25 boats a winter. These boats, of unparalleled quality, sold for $200 each.

George Andress's great-grandson Jim once offered to take his family's skiff into the eelgrass marshes off the east end of Hay Island, and there set out his father's decoys as if for an early morning duck hunt. My husband and I met Jim and a friend at 6 a.m., just as the sun was turning the waves into golden ripples. Before us were the famous Andress

black duck decoys and the equally renowned Andress skiff. We saluted Jim's skilled ancestors with photographs, a hot thermos of coffee and a silent thank-you.

In the early 1900s, as outboard motors took over the fishing and transportation needs of islanders, locals and tourists, the St. Lawrence skiff declined in popularity. In the 1950s fibreglass replaced wood for most boatbuilding, and the old skiff patterns were placed in storage. Today the best examples of the St. Lawrence skiff may be seen in the museums at Kingston and Clayton, or in the water at the antique boat shows in Clayton and Alexandria Bay.

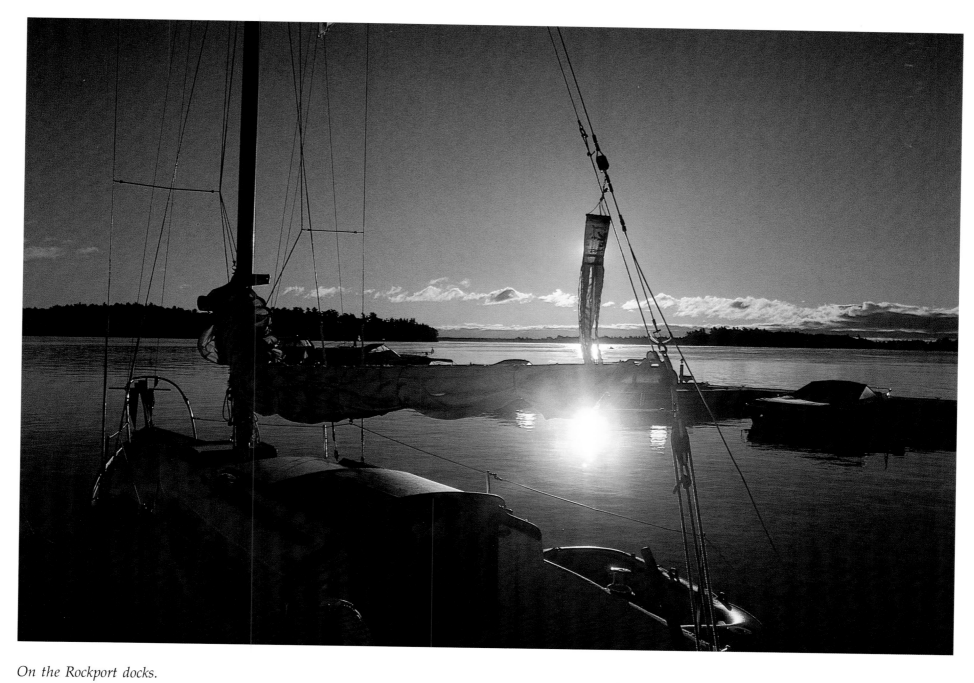

On the Rockport docks.

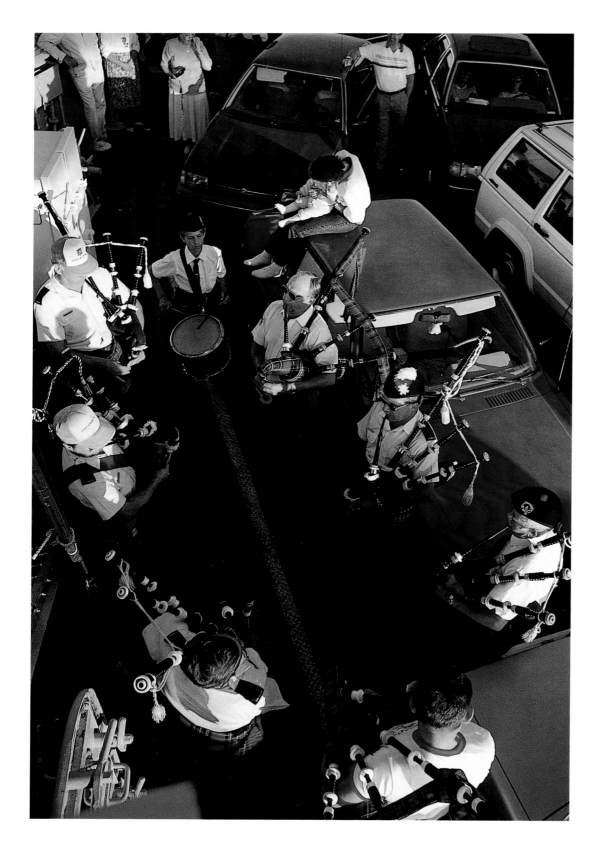

After participating in the French Festival at Cape Vincent, New York, some bagpipers from Kingston put on an impromptu concert aboard the Wolfe Island ferry.

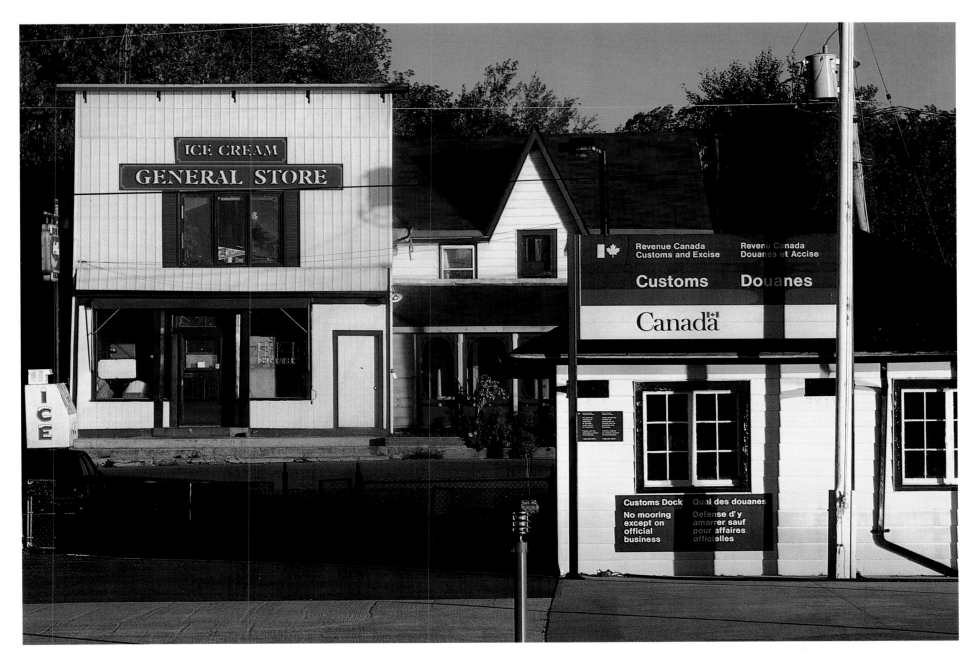

Rockport Canadian Customs House and General Store.

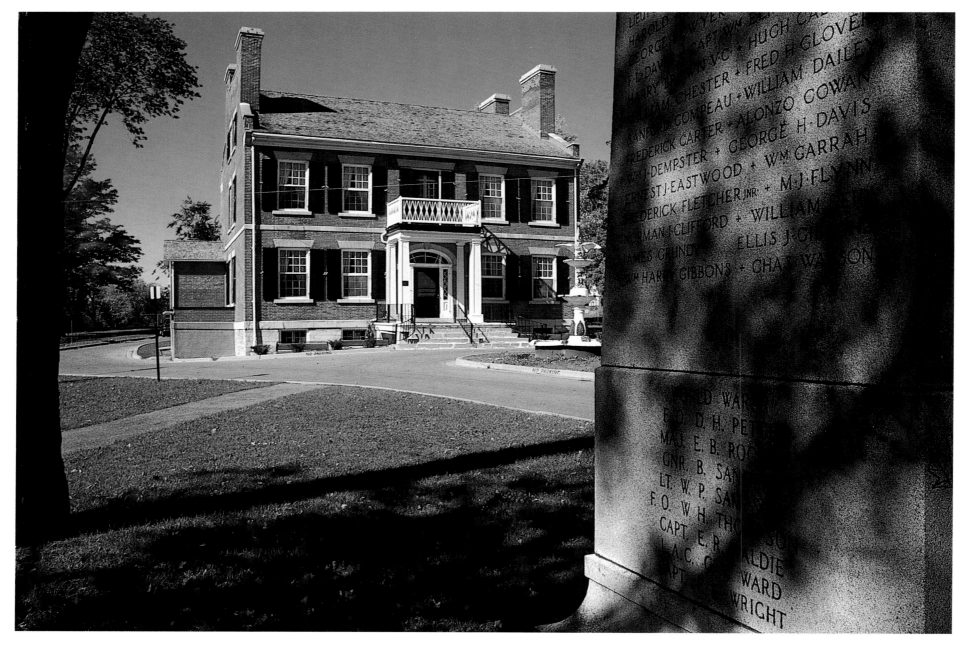

The Hon. John McDonald had this lovely Neo-Classical house built for his bride in 1831 from locally produced brick. It is now the Gananoque Town Hall. The cenotaph commemorates the men and women of the town who gave their lives during the two World Wars.

GANANOQUE: GATEWAY TO THE 1,000 ISLANDS

Gananoque is truly the Gateway to the 1,000 Islands. From Gananoque eastward the islands proliferate and become almost uncountable. This small but active community meets the needs of local residents, islanders, visitors and sailors.

It is often difficult for newcomers to know how to say "Gananoque." It comes from the language of the Mississauga Indians and means, depending on which source you consult, "a place of good health," "a place where the water runs over the rocks," or "land sloping towards and sinking under the water." According to a local guide, Gananoque has been spelled 55 different ways over the years, but it is pronounced in the Indian way, with the *que* pronounced *kway or kwee.*

The town is bisected by the Gananoque River. Its 20-foot waterfalls, located close to the centre of town, once powered saw and flour mills. But not far away the river becomes a quiet stream that reflects the image of every boat, tree and heron it encounters.

Gananoque's main street is only a few blocks long, but in summer it teems with tourists looking for English woollens and china, and in early winter the street is abustle with Christmas shoppers. There are good restaurants, hotels and motels, and stores that carry the latest in fishing tackle and marine supplies. You can also buy the *New York Times* or find someone to give expert advice on the building of a new dock or roof. For entertainment there is the excellent ex-Canoe Club Playhouse theatre.

The Gananoque Town Hall is central to the town. It is located near the east bank of the Gananoque River and is surrounded by a lovely park full of old trees. Built in 1831-32 by the Honourable John McDonald, a merchant and later a member of the Legislative Council of Canada, it is one of the finest examples of Neo-Classical architecture still standing in Ontario. John McDonald, with his brothers Charles and Colin, owned mills and immense tracts of land on both sides of the Gananoque River. John married his wife, Henrietta, and built this handsome and fashionable house the same year. Known as McDonald House, it was donated to the town in 1911 by John McDonald's descendants and has been repaired and refurnished by many generous donors. It is now used for Town Council meetings.

At Gananoque Harbour tour boats and all manner of craft are constantly coming and going. Old family boat sheds line up alongside modern marine facilities, including both permanent and temporary boat slips. Nearby you can see the huge barnlike boatbuilding workshops where the tour boats are constructed.

The last stop for locals is the wall at the attendant's booth on the town's gas dock. Here the vital messages of the community are posted: "Babysitter and second-hand outboard wanted" and "Sorry, I can't make it at 6 o'clock."

A Gananoque Boat Line tour boat alongside the "House of Haunts" at the town dock.

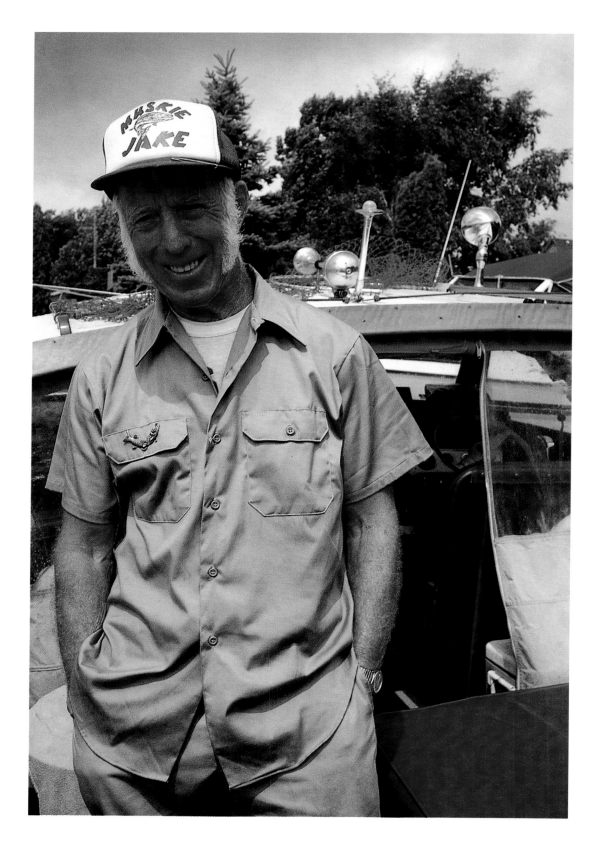

One of the best-known guides in the 1,000 Islands, "Muskie Jake" Huntley works from the Gananoque Inn dock. Since his return from five years' service in the Royal Canadian Air Force during WW II, he has plied his craft as guide and expert muskie fisherman in the waters of the 1,000 Islands.

JUNIPER AND THWARTWAY

Juniper Island has had a reputation as a hospitable, friendly family island for many years. Its cottages dot the shoreline of its seven acres, and in contrast to its many grand old summer homes, there is a central low-lying building for cooking, eating and just getting together to sit and talk. Flags, photos and mounted fish adorn the walls. There is a slot machine with a ready pile of nickels, and the ever-present backgammon board. This building is the heart of Juniper Island activity, whether the family gathering numbers 5 or 50.

To get to Juniper, you embark from Gananoque city dock and head straight south, leaving Tremont Park Island to port (left). Proceed into the channel between Hay and Forsyth, past small Eaglescrag and Moneysunk to the starboard (right), with the rest of the Admiralty Islands on the same side. Now past the end of Hay and Kalaria, past Huckleberry, Little Huckleberry and Bevcath. And there you are, at Juniper Island, with Leek Island (now Thwartway) nearby.

Once you have checked out all the surrounding islands and their names on your charts, you will be certain that this really is the 1,000 Islands. The family who owns Juniper Island zips through these islands very easily, but strangers must creep along in their boats, careful not to get lost in this beautiful puzzle of islands and channels.

Juniper has seen five generations of the same family. The great-great-grandfather of the children playing along the shore came here from New York. He chose to bring his family to the Canadian side of the river, perhaps because it was not so developed as the American side. The deed to the property shows that it was one of the islands originally purchased from the Mississauga Indians.

In the old days the family arrived at Juniper on one of the seven daily trains that came into Clayton. The boatman had their launch waiting. Since they spent the whole summer on Juniper, their bags and hampers were often sent in advance, and by the time they reached the island, the beds would be made, the cupboards stocked, and everything readied — with the help of a cook, two or three maids, a nanny and boatman.

The current generation of youngsters swims off the same rocks where their ancestors, dressed in long, white summer dresses, once took tea. One of the family members turned the little old icehouse into an island museum, collecting all manner of bits and pieces relating to Juniper's history. Just offshore, on days when the water is still, you can see a rusting old Model-T Ford, once essential to island life. One summer a birthday-present donkey provided island transportation, much to the delight of the children and the exasperation of adults. The photos on the walls tell the story of a rich, ongoing family life on Juniper Island.

Thwartway Island, now part of the St. Lawrence National Park system, is separated from Juniper by only a narrow channel. Yachts regularly anchor in its coves and bays to take advantage of Thwartway's sandy beaches (rare in the 1,000 Islands).

Thwartway was originally called Leek Island and its story is a bittersweet one. It was purchased just after the turn of the century by the Kipp family of New York. The Kipps

Timeworn log cabin.

Witnesses to the passing of the generations, yellowing family photographs and old possessions provide both nostalgic memories and quiet continuity.

built their lodge, cottages, docks, farmhouse and barns with imagination and care. Quite unique to the island, all buildings were constructed entirely of logs, and all the logs were cut on the island. The main lodge was topped with a third-storey tower. Each member of the family had a separate cottage, and these cottages were connected by lighted footpaths that wound through the trees to the water's edge.

Toward the end of World War I the island became a convalescent home. The Kipps helped with the care of the recovering officers. (When daughter Kay married, she wore her Red Cross uniform to greet her guests as they arrived by train from New York City.) Every summer, from early May until late September, the Kipp family came to their much-loved Leek Island. Between the wars Mrs. Kipp established the

popular Golden Apple in Gananoque. During the Second World War the island once again became a rehabilitation hospital, capable of holding up to 60 patients.

Sadly, the main lodge burned down in an accidental fire. A second blow rocked the family when the federal government announced that it wished to expropriate the island for a national park.

The family left Leek Island and moved to Gananoque. The wonderful log buildings were taken down, and the island's name was changed from Leek to Thwartway. Memories of Leek Island and the Kipp family still linger, but it is good to know that the loveliness of Leek is preserved through Thwartway's national park status.

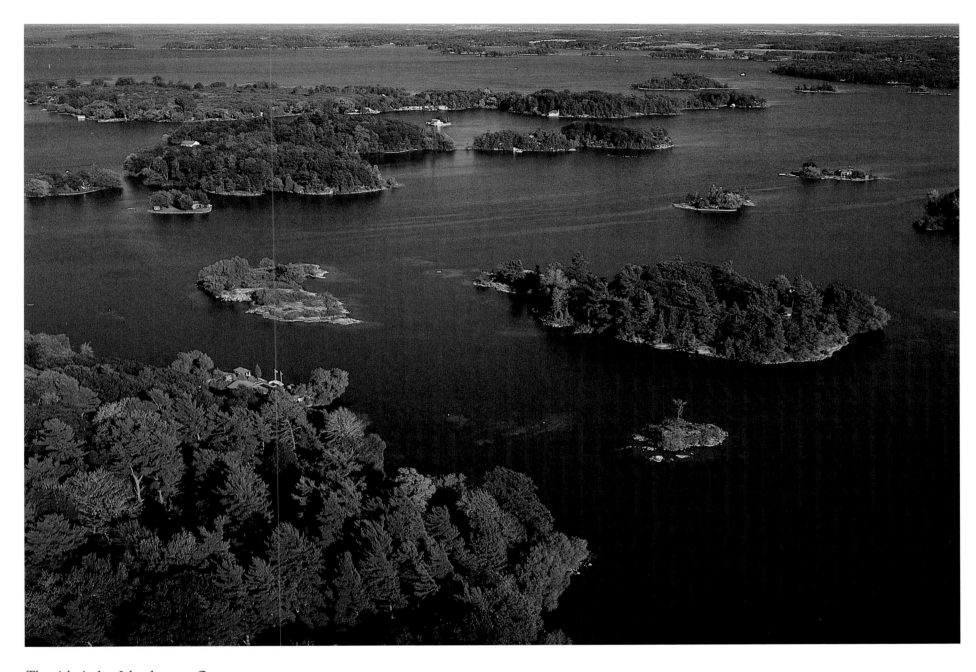

The Admiralty Islands near Gananoque.

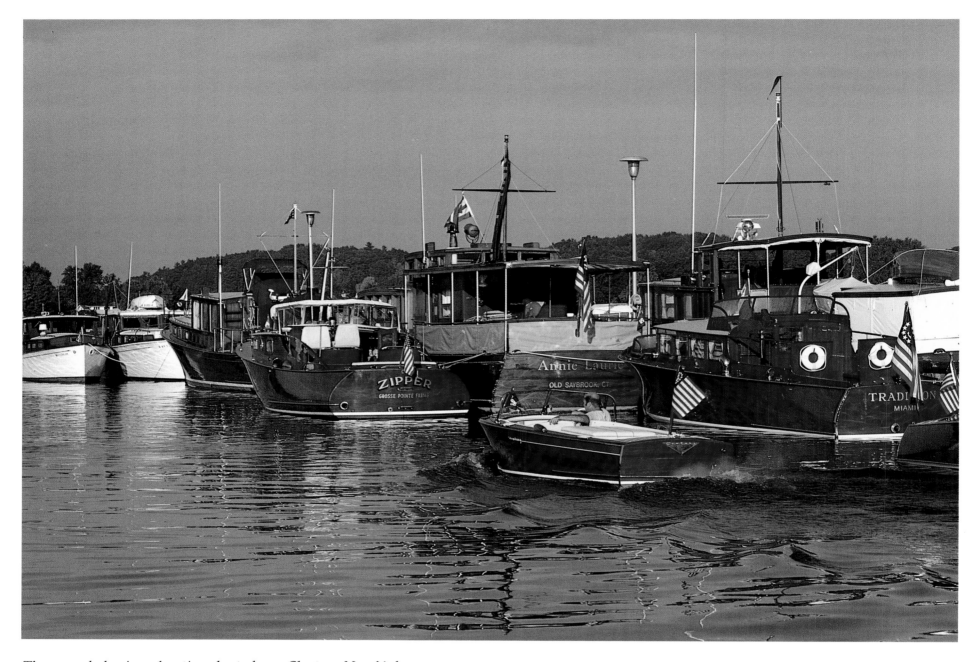

The annual classic and antique boat show, Clayton, New York.

THE BEST OLD BOATS COME TO CLAYTON

Each summer Clayton hosts one of the best antique boat shows in North America. The show features every type of antique wooden watercraft imaginable. The judging is serious and the competition is stiff, but the owners of these magnificent boats have put hundreds of hours of work into their restoration, and the Clayton Antique Boat Show is the perfect showcase for their efforts. Here old-boat aficionados gather to display their refurbished classics, exchange ideas and discuss restoration techniques. The show is truly a "main event" on the 1,000 Islands' summer agenda, and people come from all over to attend. In 1989 a number of beautiful old commuter launches and their owners took three months to make the return trip from Florida to Clayton, just to take part in the show.

Clayton is also the home of the 1,000 Islands Shipyard Museum, which features a fascinating variety of old skiffs, runabouts and steam launches on permanent display.

Clayton's main street borders the river, with the backs of many stores practically hanging over the water. In earlier years, as many as seven trains a day pulled into the small town's terminal, bringing island families, visitors, fishermen and tourists from New York City and points along the way.

The town was settled by 1823, and it was a major shipbuilding centre through the 1800s. It was also a place for troops to mobilize and a home to Pirate Bill Johnston. Legend has it that Pirate Bill once swaggered down the main street with his guns in his belt and a $500 bounty on his head, sure that none of the townspeople would turn him in.

While Clayton's summers revolve around boats and boating, in winter all thoughts turn to fishing. The Clayton Fishing Derby is held toward the end of January, when the ice on the river is thick enough to hold cars, fishing huts, and groups of fishermen huddle together in conference over a hole in the ice. The object of the competition is simple: the fisherman with the biggest fish wins the derby. Late on a frigid Sunday afternoon an anxious crowd packs into a small hall for the presentation of prizes. Outside, a huge white display board holds the fish and states their respective lengths and weights. Inside, in the dim light, stamping, steaming fishermen in heavy snowmobile suits — the temperature outside is only 15 degrees Fahrenheit — drink beer, laugh and speculate on the judges' credibility. This year the $600 first prize is awarded for a 38-inch Great Northern Pike weighing 16 pounds 4 ounces. No one doubts there will be a bigger fish below next year's ice, or that he or she will be the one to catch it.

Classic and antique boat show, Clayton.

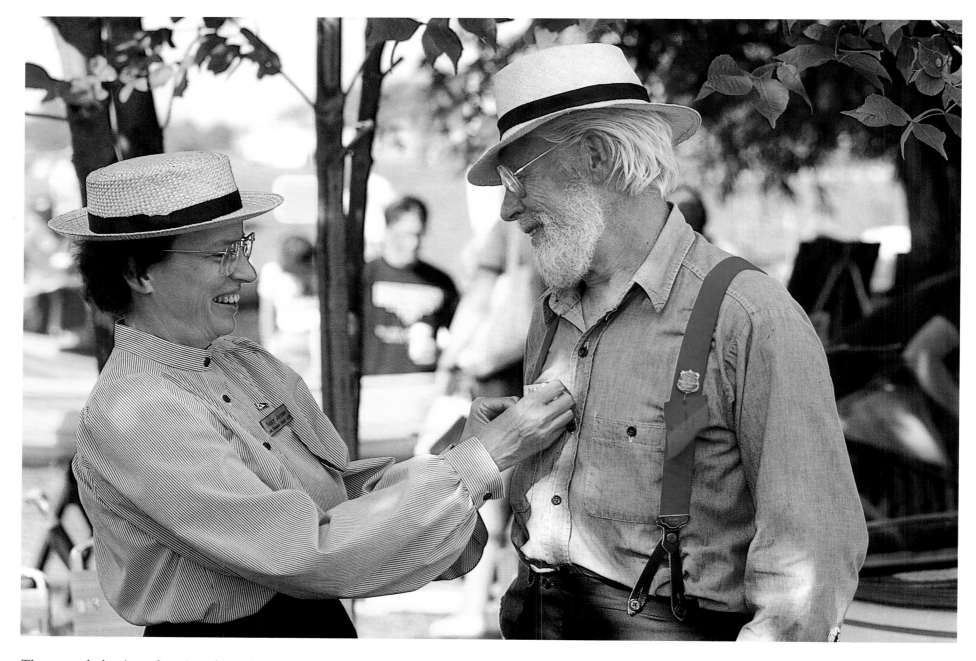

The annual classic and antique boat show at the Shipyard Museum in Clayton, New York, draws truly fabulous boats from far and near. The Jeromes of Vermont, canoe exhibitors, add some New England flavour to the show.

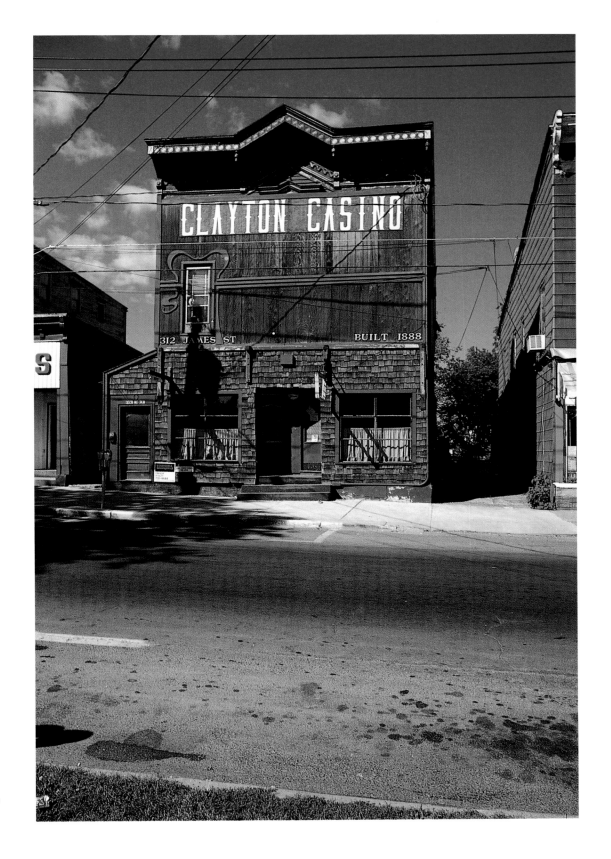

The Clayton Casino, built in 1888, stands near the centre of town.

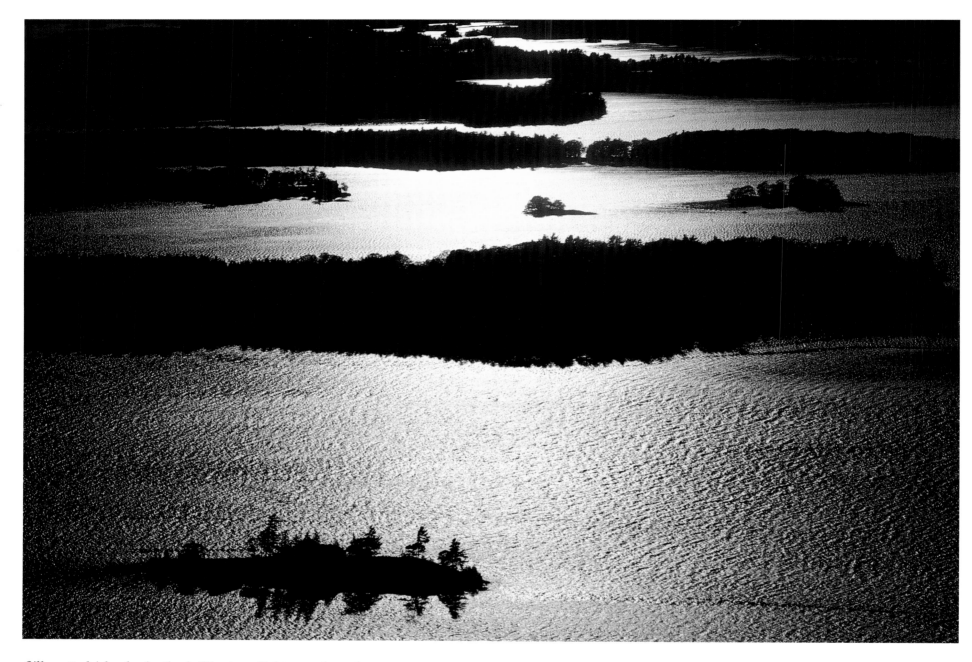

Silhouetted islands, in the brilliant sunlight on a late afternoon.

THE *SIR ROBERT PEEL* & PIRATE BILL JOHNSTON

Just off Grenadier Island, opposite Mallorytown, there are three islands, Peel, Little Peel and Robert, all near Peel Shoal. These islands were named for the *Sir Robert Peel*, a steamer captured by Pirate Bill Johnston, grounded on a shoal and burned on May 29, 1838. Johnston was a notorious Canadian renegade, pirate, deserter, spy and scalliwag who called himself the Admiral of the Patriots' Navy — a navy which had no ships.

Having taken on wood for fuel, the *Sir Robert Peel* was docked at McDonalds Wharf on Wellesley Island. Late at night 20 of Johnston's men, dressed as Indians, swooped out of the darkness, captured and looted the ship, then escorted the passengers (some still in night dress) onto the shore. The pirates then headed downriver with the *Sir Robert*. When the steamer grounded, she was set on fire and Johnston's men escaped in small boats. The total loss tallied nearly $175,000.

Lord Durham wrote, "We left Montreal on July 10 and passed through the 1,000 Islands where Pirate Bill Johnston and his gang hang out. The islands are perfectly suited for his purpose. They are nearly 1,800 in number, uninhabited, rocky, covered with wood, and so close together that a steamer in passing almost touches the overhanging trees. Concealment itself therefore is easy."

Johnston had a long-standing grudge against the British. At the start of the War of 1812 he was convicted as a spy and put in prison. Upon his release he crossed the border and, making the 1,000 Islands his base, harassed the convoys carrying British supplies upriver.

In 1814 the huge British man-of-war the *St. Lawrence* was near completion. This naval vessel soon became the focus of Johnston's attention. "What a thing it would be to sink her!" he must have said to himself. So he built a torpedo, using a copper casing filled with explosives, and he and a friend set out one night with plans to enter Kingston Harbour, lay the fragile torpedo beside the *St. Lawrence* and send the ship to a watery grave. To the pirates' dismay, they couldn't find the ship, and they were instead forced to row carefully and quietly back across the river to their hiding place behind Garden Island.

Pirate Bill Johnston's exploits were often more successful and sometimes quite profitable. He was often in the news and was a persistent nuisance to the area's authorities. He operated out of Clayton and the nearby islands. His wife lived in Clayton, his sons were often with him, and his daughter Kate is said to have supplied him with food wherever he happened to be hiding. Kate Johnston was known locally as the "Queen of the 1,000 Islands."

Crossover Island.

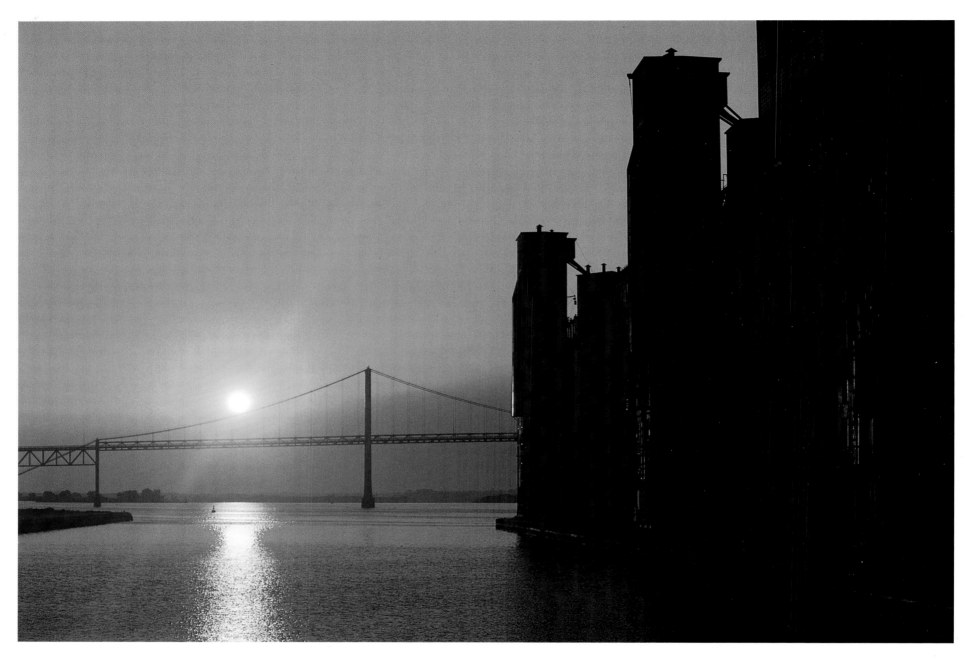

The international bridge between Prescott, Ontario, and Ogdensburg, New York, forms an easy eastern "border" to the 1,000 Islands. Visitors to the area can enjoy a pleasant circular drive by using the two international bridges or the Prescott bridge and the Cape Vincent to Wolfe Island to Kingston ferries. Grain elevators, such as the ones in this picture, were essential for the transshipment of mid-western grain to the east coast and Europe until the 1950s. Their usefulness disappeared with the completion of the St. Lawrence Seaway.

THE 1,000 ISLANDS INTERNATIONAL BRIDGE

The 1,000 Islands International Bridge links northern New York State with Ontario across Wellesley Island, with the American span crossing the South Channel of the St. Lawrence and the Canadian span crossing the North Channel.

For 40 years prior to the bridge's conception, in 1920, the 1,000 Islands had been a summertime playground for Canadian and American residents. Boating, fishing, camping, sightseeing and cottaging had drawn more people each year. The area was easy to reach by railway, and there were ferries linking most of the shoreline towns, but it was still thought that a bridge across the great river would be a tremendous benefit to both countries.

By 1933 the bridge was on the drawing boards, with agreements from all necessary authorities. There were to be five spans: the two major suspension bridges and three smaller spans.

Construction was well under way in 1937 — the concrete foundations, the crisscrossed iron roadbed, the huge hanging cables that reached 800 feet between the 220-foot towers.

A year later, on August 18, 1938, the spectacular bridges were officially opened by President Franklin D. Roosevelt and Prime Minister Mackenzie King. World War II was fast approaching, and in those uneasy months the bridge project was a symbol of co-operation between the two nations. As the ribbons were cut, President Roosevelt said, "The best symbol of common sense is this bridge." The bridge was now the crossing point for miles of unpatrolled border. Roosevelt looked to the Canadian delegation and added, "Pass, Friend."

"Pass, Friend" could well be the watchword on the bridge. In its first 30 years, 14,439,755 vehicles carrying 50 million passengers crossed the international spans. Today more than 5,000 cars a day make the crossing. If you live near the bridge the constant rumble of trucks at night is a reminder of the magnitude of our countries' international commerce.

The bridge turned 50 in 1988 and the celebrations were on a scale worthy of such a grand event. A parade of boats four miles long made its way from Alexandria Bay to Rockport, upriver and under the Canadian span, and around Wellesley Island to Clayton. There were boats of all ages and sizes, anything that could float took to the river on that sunny afternoon. There was also a touching moment when two women, one Canadian and one American — just little girls at the original ribbon-cutting ceremony — hugged each other in celebration 50 years later.

Ralph Smith, who lives near Lansdowne, close to the border, worked on the bridge's foundations and substructure. His friends were high-wire men, riveters and cement-mixers, but he helped set the footings for the towers that carry the suspension cables. On the Canadian span the first footing was blasted at the water's edge. There were no steam shovels to aid the workers, so each rock had to be carefully handed from scaffold to scaffold.

Smith also worked on a small raft pumping air to the diver who was moving rock and preparing the base for the tower. Smith remembers the diver's old diving suit with its 200 or more bicycle patches holding out the water. Every few hours the diver was hauled out and his suit was emptied.

"This is no ordinary bridge," says Smith. "This is the

Wind-swept parking spaces at Brown's Bay Provincial Park in winter.

bridge of bridges. It combines two cantilever suspension spans, an arch span, and a Warren truss span. With its linking highways, that makes eight and a half miles of bridge corridors. The suspension cables are made of 37 one-and-a-half-inch intertwined strands of steel buried in concrete. Everything had to be exact and perfect. Every joining bolt fitted exactly. We took a lot of pride in our work and now look — we still have a perfect bridge. She's a wonder, and I helped build her."

The second span was to have been anchored on the shore of Wellesley Island, but a local river man, Andrew Truesdell, happened to be driving chief engineer Jim Christie around the site. Truesdell wondered why the shoal, only 18 feet underwater, was not being used as the anchor point. Christie examined the shoal, plans were redesigned, the span was shortened by 400 feet, and the cost of the bridge was reduced by a million dollars.

Mrs. Truesdell, who lives in Ivy Lea Village, was also at the 50th anniversary celebration. Her husband Tom ran a scow for transporting materials to the site. For her part, she boarded seven labourers, feeding them colossal meals while looking after four small children at the same time.

Before the bridge was built, hundreds of ferryboats serviced the island and river communities. The last ferry trip was made when the paddlewheeler *Britannic* called at Mallorytown Landing in 1938. She was redundant the day the bridge opened.

The boats that the bridge replaced should not be forgotten. These boats were once the workhorses of the river, transporting people and goods to destinations up and down the mighty waterway in all kinds of weather.

The first paddlewheel steamer in the area was the *Frontenac*, built in 1816 at Bath, Ontario. Her overall length was 170 feet, and she was schooner-rigged in case of engine failure. Her cost was $100,000 — a whopping price in those days.

According to Tencate and Fryer, in their book *The Pictorial History of the 1,000 Islands*, the small steamer *William IV* came off the skids in Gananoque in 1831. She was 135 feet overall, 220 horsepower, and had 4 funnels and a central paddlewheel. (I have a special soft spot for the *William IV*

because, according to a local newspaper, my great-grandfather was purser on this boat as she plied the river between Prescott and Kingston.)

A typical story of a paddlewheeler might be that of the *Kingston*. She was built in 1833 and was replaced by another *Kingston* in 1855. The second *Kingston* was used as a Royal Yacht, carrying the Prince of Wales (later Edward VII) to Toronto in 1860. Damaged by fire in 1872, she was refitted and renamed the *Bavaria*, burned again, renamed the *Algeria*, then sold and renamed the *Cornwall*. She finally sunk in 1928 at age 73.

The names *Island Belle, Island Wanderer* and *Island Queen* persisted for many years. The *Bonnie Belle*, currently in service, is a small tour boat with a fake paddlewheel that gives it a quaint old-fashioned look as it makes its way around the islands.

The old-time paddlewheelers were joined by the luxury steam launches of the more affluent, and the huge river and lake passenger vessels that could carry 2,000 people and sleep 500 on their overnight trips across Lake Ontario. Today companies on both sides of the river operate tour boats. You can choose a triple-decker or a small, low-to-the-water old-timer.

After the International Bridge was built, when boats became more pleasure craft than necessary means of transportation across the river, the people of the 1,000 Islands and the river mainland entered a new era, one of yachts, cruisers and small outboards.

The bridge has dramatically changed river life. It was also part of a puzzling rite of passage. To celebrate the end of exams, Queens University nursing students cross the bridge for a night on the town at one of the many U.S. resorts along the river. In earlier years it was the tradition for graduating nurses — who change their stockings from black to white upon successful completion of their course — to take their old black hosiery to the top of the bridge and fling them out into the St. Lawrence in the wee hours of the morning, on the return trip from their celebrations. It must have shocked many a fisherman or pleasure boater to see those black stockings floating downriver at dawn.

ALEXANDRIA BAY

Sooner or later everyone in the 1,000 Islands arrives at The Bay. Alexandria Bay (known locally as Alex Bay or simply The Bay) is central to life on the river. It provides groceries, boat-engine repair, boat tours, the only year-round riverside hospital, fine restaurants, and a variety of entertainment for all comers. It makes itself known with no less than 32 huge roadside signs. On a warm summer evening Alex Bay's night life attracts locals, cottagers, tourists, even soldiers from nearby Fort Drum. A carnival atmosphere surrounds the many cafes, restaurants, bars, souvenir stores and fudge shops.

Like other river towns, Alexandria Bay is a mixture of fun-seeking visitors and year-round townsfolk going about their business against a backdrop of businesslike lake freighters, loaded tour boats, and flashy speedboats with their throbbing engines and splashing rooster tails.

The town was first surveyed in 1818 and named for Alexander Le Ray de Chaumont, the son of French Count Jacques Donatien Le Ray de Chaumont, who owned some 220,000 acres along the river. Alexander was killed in a duel in 1836.

Alexandria Bay started as a lumbering centre. Later ship-building took over (the Hacker boatworks are close by). Large, luxurious hotels were built along the shoreline. The Bay was also the launching point for the crews of workers who built many of the extravagant mansion-cottages that have dominated the 1,000 Islands throughout their history. Many of the Italian-American residents of Alexandria Bay are descendants of skilled workmen who came from Italy to help build Boldt Castle. When the work stopped, these labourers were stranded without jobs and without the money to return home.

One of the important sights to see in Alex Bay is the A. Graham Thompson Museum at the corner of Market and Jane streets. Its clean Colonial lines are in sharp contrast to the newer entertainment centres only a few hundred feet away.

Captain A. Graham Thompson's house, now a museum, Alexandria Bay.

The Bonnie Castle Stables, just outside Alexandria Bay and near the U.S. span of the 1,000 Islands Bridge, are a year-round resort featuring concerts, special events, wintertime parties and hayrides.

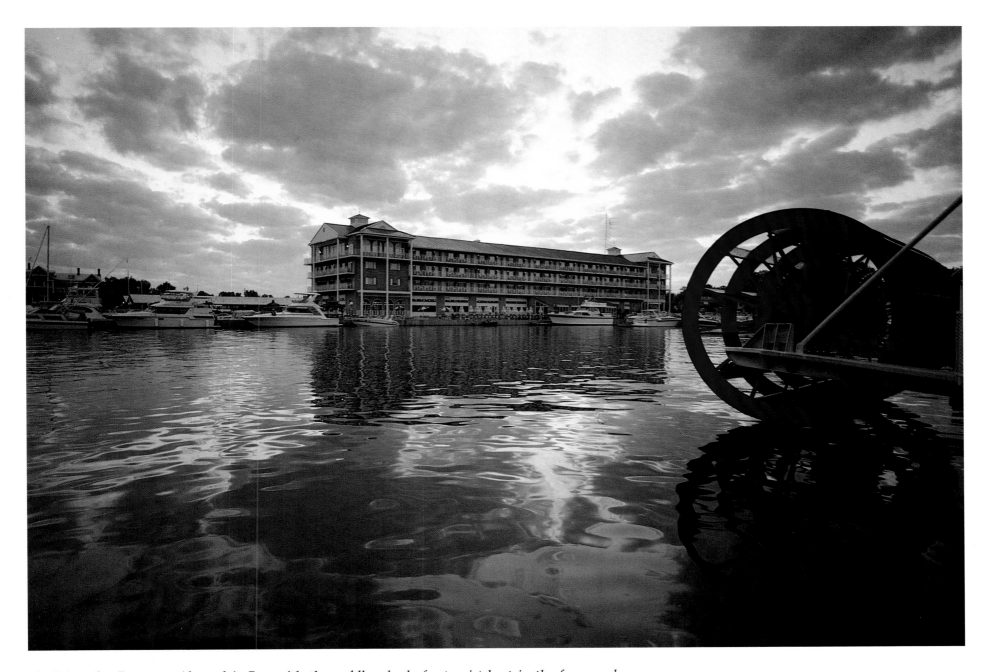

The Riveredge Resort at Alexandria Bay with the paddle wheel of a tourist boat in the foregound.

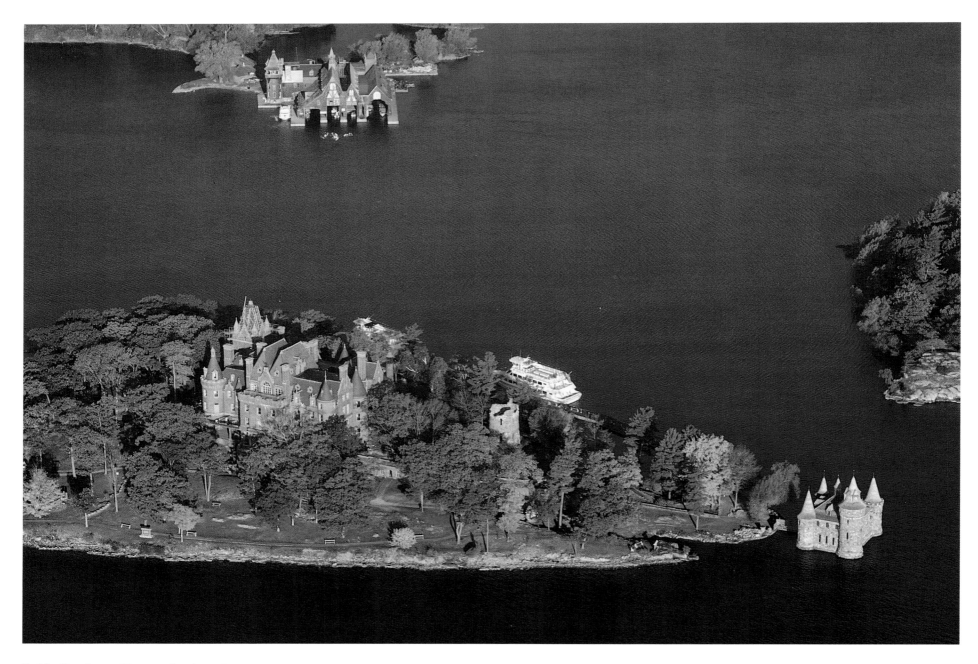

Boldt Castle on Heart Island with tour boat. The castle's pump house is at right and the huge boathouses, tall enough to take a yacht with stepped mast, are across the channel.

BOLDT CASTLE

In 1894 George Boldt, owner of the Waldorf Astoria Hotel in New York, visited the Thousand Island Club, then located on Bethune Street in Alexandria Bay. He was immediately captivated by the beauty of the 1,000 Islands region.

Soon afterward Boldt bought Heart Island and laid plans for a grand Rhineland-style castle. The castle was to be a monument to the love of his life, his wife, Louise, and was to include 11 buildings, 120 rooms in total, including ballrooms, library, elaborate dining room, and a billiard room.

Work began on the project in 1900. First, the island was dynamited into the shape of a heart. Then granite for the buildings was quarried on Oak Island and transported ten miles to the construction site. George Boldt employed European craftsmen and every skilled builder on both sides of the river to work on his $5-million dream home.

The vast estate included not only the 11 castle buildings, but also huge boathouses for yachts with stepped masts, and a fleet of steamboats and launches. On Wellesley Island, 1,500 acres were designated for farms, polo fields, six villas, and the 50-room Wellesley Farms cottage, which could accommodate 40 guests. Even today the extent of Boldt's imagination and love for his wife boggles the mind.

When Louise Boldt died two years later, in 1902, heartbroken George Boldt halted all construction and left the 1,000 Islands, never to return.

Visitors from all over the world come to see romantic Boldt Castle and to hear the tragic story of a New York millionaire's unfinished dreams. Boldt Castle is the number-one tourist attraction in the 1,000 Islands. In 1989 more than 175,000 people visited this most out-of-place monument.

The preservation and restoration of Boldt Castle has been undertaken by its present owners, the 1,000 Islands Bridge Authority of New York.

Over 175,000 visitors came to Boldt Castle last year, many aboard the Gananoque Boat Line.

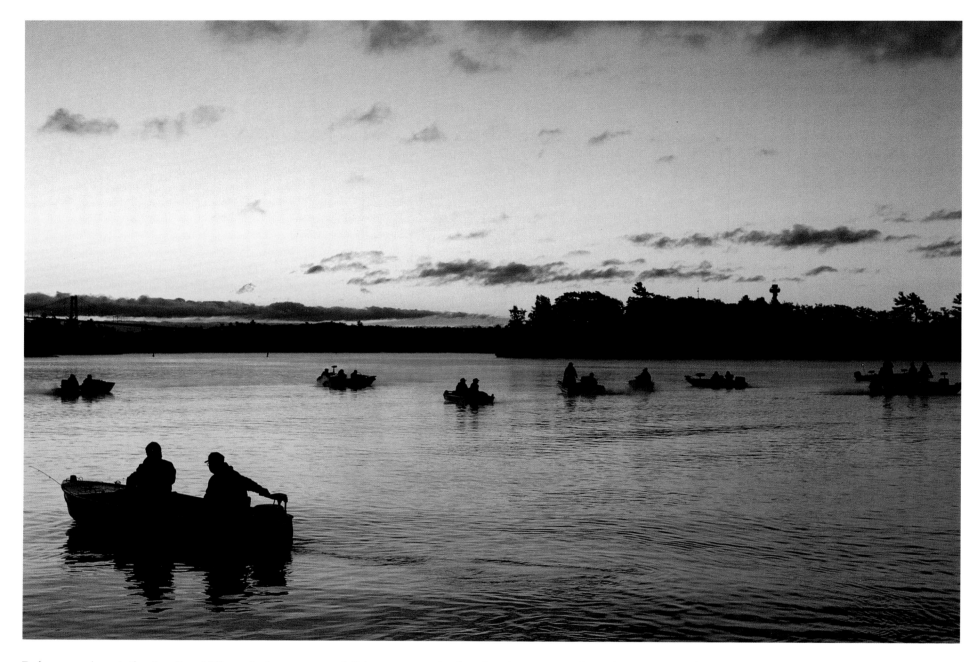

Before sunrise at the Ivy Lea Village dock, a group of fishermen await the signal to start a day of competitive fishing.

CATCHING THE BIG ONE

The sun is just getting up. It is chilly and there is a slight mist on the water. A heron stands on the point. Inside the cottage the children are creeping around, whispering to themselves, trying not to wake the bigger people but impatient to get started. At last an adult wakes and says, "Let's go catch the Big One."

In our family, enthusiasm for catching the Big One never wanes. Eagerly we collect worms, tackle, fishing net, corn flakes, juice, and off we go — low in expertise and technique, but high in optimism and passion for just being out there where the fish are found.

In truth, the biggest bass we've ever caught near our island leaped onto a baited hook attached to an ordinary piece of string being trailed about ten feet behind our outboard. We were on our way to buy milk; fishing certainly wasn't foremost on our minds. The string was in the hands of a four-year-old boy when the bass struck. When we finally got the fish aboard, he was so big we could hardly get him into a pail of water. We forgot about the milk and hurried home to show off our catch, our aged-four angler beaming all the way.

Despite our generally poor luck on these frequent fishing expeditions, we are never discouraged. We fish, catch little, change bait, discuss what might be wrong, change spots. We mosey around until we run out of time. We fish in the rain — even in thunderstorms. We fish when it is hot and when it is bitterly cold.

One truly miserable day everyone was playing cards around the fire, bored and irritable. The fighting started.

"Let's go catch the Big One," someone suggested. There commenced an immediate truce as slickers, sweaters and umbrellas were gathered. The spirit of adventure prevailed and we were off. Another time we had six children lined up along the dock with old rods and only worms for bait. In half an hour we had 45 fish in the pails, each captured with much giggling and excitement. Some of the children had never caught a fish before, but now they were as hooked as the rest of us, sectioning their worms in halves and quarters to make the bait last, no longer requesting a veteran's assistance.

It was the splendid fishing that drew the first sportsmen to the 1,000 Islands. They came to fish, were captivated by this beautiful place with its fresh air and fresh water, and couldn't wait to return. Hotels were erected, homes and cottages were built, skiffs were constructed. Gentlemen fishermen abounded. Thomas Alvord was a keen fisherman and Governor of New York State. In 1892 he wrote: "I have returned to the St. Lawrence for over 40 years again and again, fishing for the gamiest fish that can be found in fresh waters. I have traversed every nook and corner, islet and island, every shoal and deep of the St. Lawrence, and any day upon the water, I have neglected my rod to drink in the invigorating air and the wonderous and indescribable beauty."

When Governor Alvord first came to fish the river, he was content to use the equipment provided by his guide: "A naked wooden pole. The spoon for trolling was just an iron or pewter spoon with a big, coarse hook brazed on. There was no swivel. It wobbled in the water."

Every year thousands of fishermen come here to fish.

Gananoque taxidermist Ed Shaw with a fierce 37-pound muskie.

They fish from the shore, from mainland docks, from canoes, old-time boats, and the most elaborate launches ever built. The tackle box of today's angler suggests he or she has studied the habits of the river's various fish very carefully. The lures and lines have been scientifically tested. Some well-equipped fishermen even employ a variety of electronic devices to ensure their success.

Biologists at the Ontario Ministry of Natural Resources say that many fishermen now catch and release their fish. This way, a large bass can be caught eight to ten times, still leaving it free to reproduce.

The muskie (muskellunge) is the king fish of the river. The world-record muskie, at 69 pounds 15 ounces, was caught off Clayton. The average large muskie weighs between 35 and 40 pounds. The Ontario Ministry of Natural Resources estimates that only 100 to 120 are caught each year, despite all the fishermen out for the Big One. It is the fish everyone talks about.

If a fisherman catches his hook on a rock: "It's a muskie!" If he snags a log: "It's a muskie!" If a big fish jumps nearby and slaps the water with its tail: "It's a muskie!" But if the fisherman ever does hook a muskie, he'll never mistake it for anything else again. A muskie can strike with tremendous power. It will run out all your line, leap in the air, giving you the thrill of a lifetime, then snap your leader, take your lure, and be gone.

The muskie is under careful observation by fish and wildlife authorities, and each year more is known about its habits. It is a priority on both sides of the river to protect known spawning grounds. One muskie was tagged in Chippewa Bay and followed by radio telemetry to a location in Lake Ontario, having travelled 95 kilometres (60 miles) in one week.

Telling muskie stories is one of the favourite pastimes on the river. One story has it that in the 1880s an American fisherman named Mr. Scott went fishing with a guide and caught a fine perch. As he was bringing the perch into the boat, a huge muskie leaped into the air after the perch and thus landed itself in the boat, knocking a startled Mr. Scott over. There, in the skiff, were the perch, the muskie, and Mr. Scott, all thrashing around together on the bottom of the boat. Reportedly, only two words were spoken: "Great Scott!"

An even larger St. Lawrence dweller is the sturgeon. In 1961 a 79-year-old fisherman from Ivy Lea Village caught a 165-pound sturgeon. Back in 1949 this same fisherman caught a 237-pounder (another fisherman recorded a 310-pound monster sturgeon). His wife recalls processing caviar from the roe of the eight to ten sturgeon her husband caught each year. This caviar was shipped to New York, where it was sold at high market prices. Smoked or fresh, sturgeon are delicious to eat.

For years now sturgeon have been neither seen nor caught by St. Lawrence fishermen. Perhaps the Seaway Dams (1957) disturbed their habitat and life cycle. Perhaps they were fished out. But there is hope. A few four-to-five-year-old sturgeon have recently been found in Ministry of Natural Resources monitoring nets. No one knows where they spawn — and perhaps, for now, that is a good thing.

Another denizen of the river is the American eel. Born in the Sargasso Sea, it takes them four to six years to drift into the St. Lawrence. Since 1980 over four million have gone over the eel ladder on the big dams at Cornwall. These eels spend six to ten years in Lake Ontario and are the mainstay of commercial fishing in some areas. The remaining uncaptured eels eventually return to the Sargasso Sea to spawn.

The Ontario Ministry of Natural Resources posts signs in all public parks to warn fishermen about eating the fish they have caught. Generally speaking, prolonged consistent eating of St. Lawrence River fish is discouraged, as pollutants get into the flesh of the fish. (The older the fish, the more pollutants it may contain.)

Recent pollution controls have improved conditions in the river, but more can be done to ensure healthier lives for both the Big One and small ones.

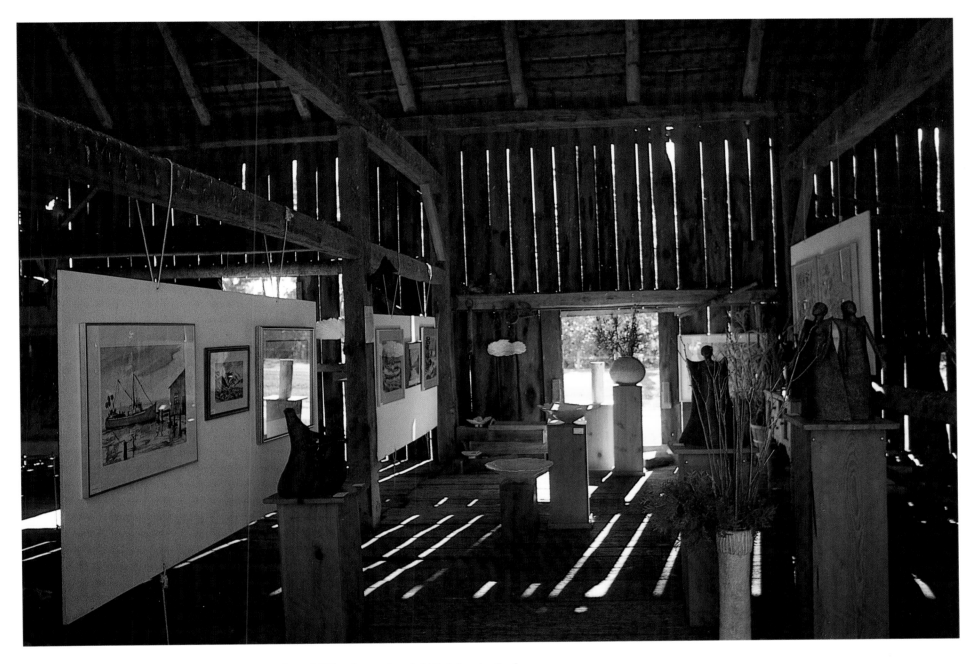

Artists' gallery and exhibition barn at La Rue Mills along the 1,000 Islands Parkway.

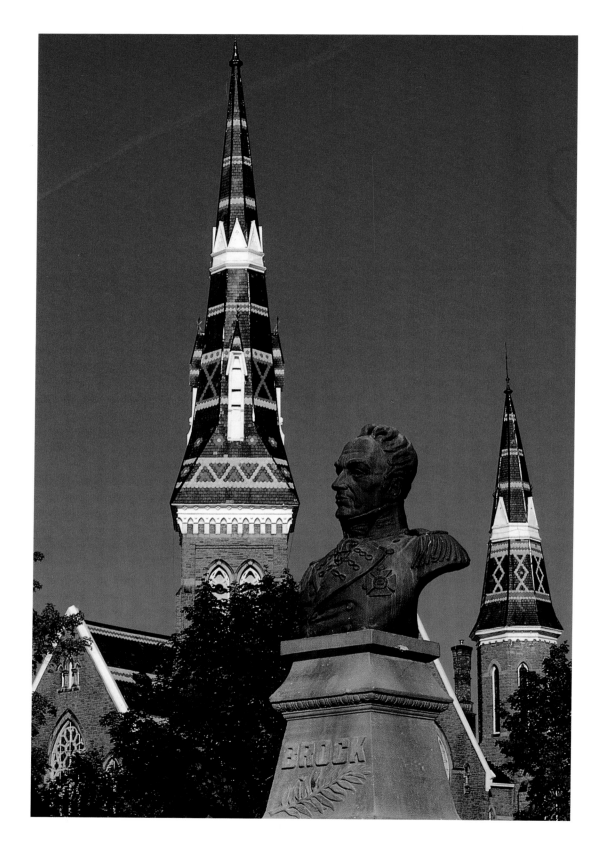

Originally called Buells Bay, Brockville took on its current name in 1816, four years after General Sir Isaac Brock, military governor of Upper Canada, was killed in the crucial War of 1812 Battle of Queenston Heights near Niagara Falls. The coloured-tile steeples belong to the Wall Street United Church.

BROCKVILLE: RIVERFEST CITY

Leaving the 1,000 Islands, heading east, the North and South channels of the St. Lawrence abruptly merge into one channel about a mile wide. In fact, the main, buoyed channel for all river traffic is only 350 feet wide and is called the Brockville Narrows. These narrows flow through the 17-island Brockville Group. The river traveller must navigate past Chub, Victoria and Mile islands... past Everest, Skeleton, Refugee and Stovin. At Stovin, a National Park Island, boats pass so close to shore that you could bat a tennis ball onto the deck of an international freighter.

A number of the small islands in the Brockville Group are public campgrounds owned by the City of Brockville. Campers may book an island campsite the same way they would a mainland campsite, and there are a number of small docks available to boaters. The many colourful tents that dot these islets on warm summer nights are themselves an attraction.

Each island has its own interesting history. On Cockburn Island, a favourite picnicking place, there is a cairn commemorating the deaths of 33 construction workers who were dredging the Narrows when a lightning bolt struck some dynamite. DeRottenburg Island is named for a general who fought in the War of 1812. Black Charlie Island is named for a refugee who hid on the island during the same war.

Some of the private summer properties near Brockville are on peninsulas which jut dramatically into the river. On one family property, the original summer cottage, built in 1887, has been joined by three additional cottages, and first, second and third cousins, big and little, spend part of each summer together. There have been three weddings here, as well as 50th and 60th anniversary parties. The main cottage's walls are filled with photographs of family occasions, drawings and maps, yesterday's memorabilia and today's projects. On most summer days, at noontime, the children don life jackets and are loaded into a boat containing an adult or two, some peanut-butter sandwiches, drinks, and other picnicking essentials. These are exciting outings to "somewhere else." Somewhere else may be Cockburn Island, or North or South Twin, or Refugee. These river kids know the names of freighters, their markings, flags and respective companies. They know where the ships may be going and what they may be carrying — in the same way seasoned car-travelling kids know the makes of cars. A four-year-old can tell you which way is "upriver" or "downriver."

An older cottager said of river life, "I wouldn't change it for any other. That mighty river is going somewhere. Sure it has a current that makes small boating and sailing difficult, but that river is useful. It seems to have a purpose. It's not just for recreation. You aren't shut away from life for summertime living."

A mile or so from Skeleton Island, the most easterly of the Brockville Group, the docks and marinas of the Town of Brockville play host to RiverFest, a summer water celebration featuring canoe races, a fishing derby, a yacht club sail-past, and a grand display of fireworks. Motorboat loads of spectators fill the water to watch today's RiverFest activities, but according to the Brockville *Recorder* a very different kind of activity took place here in 1866: "It is not an uncommon sight to see in the calm afternoons of summer, or in the long twilights, 500 or more of those skiffs dotting the surface of the water opposite and above

Brockville's RiverFest.

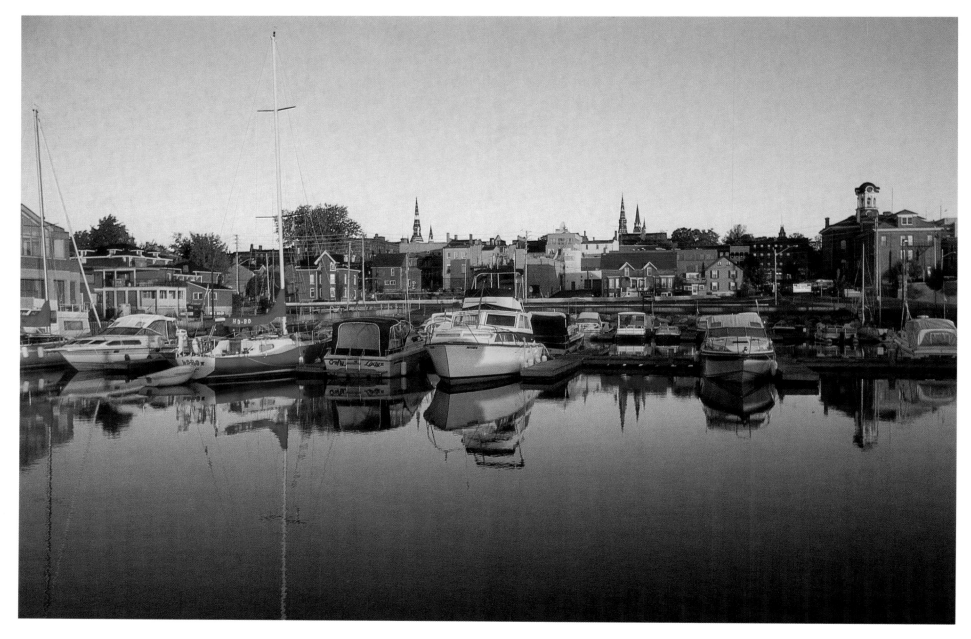

Brockville's riverfront marina at first light.

Brockville and gliding through the narrow channels among the islands."

Originally called Buells Bay, Brockville was a landing and a resting place for voyageurs and for settlers travelling to their lands. It grew into a town in the early 1800s. Today, as you walk from the waterfront to the main street, you pass several lovely old stone buildings. The Court House Square is on a height of land above the shopping area. The imposing County Court House was built in 1842. If you look up, high above the central facade, the Lady of Justice balances the scales of the law. She is almost eye level with the steeples of nearby churches, which have been decorated in patterns of coloured slate — a most unusual and original display.

The centre of Brockville during the annual Symphony of Lights. At the top of the boulevard is the Leeds and Grenville County courthouse, built in 1842.

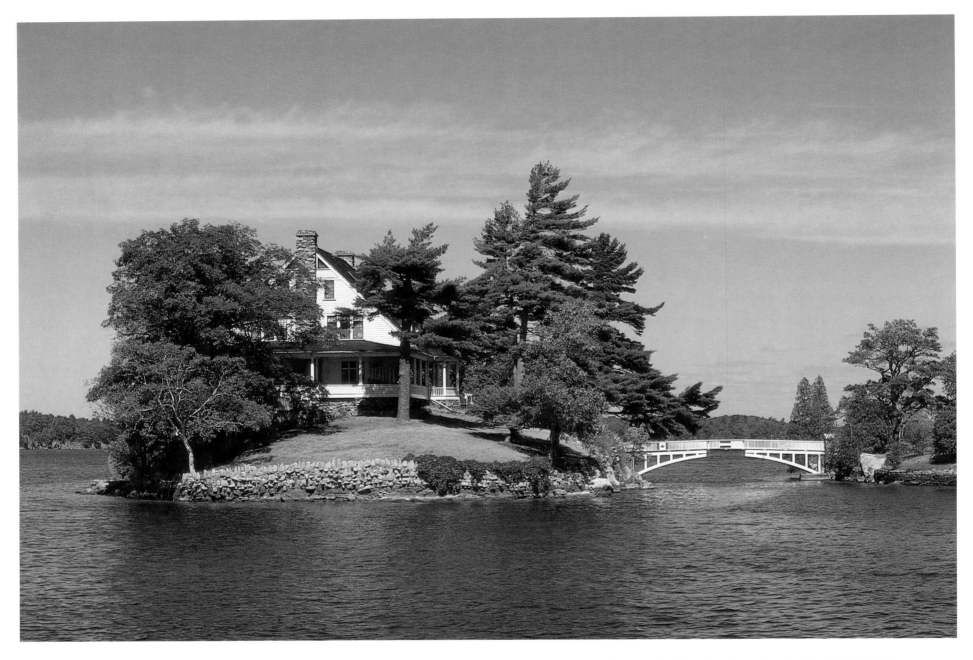

All the 1,000 Islands tour boats pass by Zavikon Island because the property consists of two islands, one in Canada, the other in the United States, making the little bridge which connects them the shortest international bridge in the world.

TOURING THE RIVER

I have a friend who often makes the run from Kingston to Brockville and return by powerboat. He has a number of alternate routes, and the trip gives him the chance to do his own private check on many of the unusual cottages on the river. Sometimes he runs around the west end of Wolfe Island and then, entering the U.S. main channel, he heads down to the International Bridge, passing the towns of Cape Vincent and Clayton on the way.

Just to the east of Clayton, and to port, the boat passes Calumet Island, where Charles Emery built his large estate before the turn of the century. His first steam yacht, the *Calumet*, was 147 feet long, with a 20-foot beam, and cost $100,000. Emery also had a smaller yacht, the Juanita, and seven skiffs. In 1897 he owned a Herreshoff-built yacht, the *Nina*. Today only a large water tower and several smaller homes remain on Calumet Island.

After passing the International Bridge, Pullman Island appears to the port side. In 1872 George M. Pullman (of Pullman railway car fame) purchased an island at Alexandria Bay and invited President Grant and General Sherman to spend a week fishing with him in the 1,000 Islands. The visit received extensive publicity, and the 1,000 Islands became widely known. Pullman built a colossal turreted house that was later demolished and replaced by a smaller version, still standing today.

A little further along, the boat nears Boldt Castle on Heart Island. Around the west end of the island, two gigantic boathouses are found in a little bay directly behind the castle. Three steam yachts (*Louisa, Clarion* and *Crescent*), a

steam tug, a sailing yacht, a houseboat with three decks, and 12 motor launches were housed here.

The heyday of the 1,000 Islands began with President Grant's visit and ended with the start of the First World War. It was a time of great excess, a time when everyone attempted to outdo his neighbour. Some properties even had stone gargoyles lining their seawalls. Today tour boats carry tens of thousands of people each summer to view the extravangances of earlier days in the 1,000 Islands.

Travelling east of Alexandria Bay, the powerboat enters a much different 1,000 Islands. Traversing the river, headed towards the Canadian Channel, the boat passes the tip of Deer Island, which has been owned for a great many years by the Skull and Bones Society of Yale University. The rambling wooden home onshore, with its slips for canoes and skiffs, remains virtually unchanged from the early days. There are no telephones, and outboard motors are still frowned upon as intruders in what is still "camp" life.

Zavikon Island, to the northeast, is in fact two islands joined by a low wooden bridge known as "the smallest international bridge in the world." The imposing three-storey house sits high above the water and is surrounded by manicured lawns.

The most direct route back to Kingston is via the Canadian Channel. Before reaching the International Bridge the boats speeds by an ancient cottage on tiny Surveyor Island, located right in the middle of the main channel. The cottage has been painted dark green with red trim. The hammock on the veranda must offer a great view of river traffic.

Channel at Alexandria Bay.

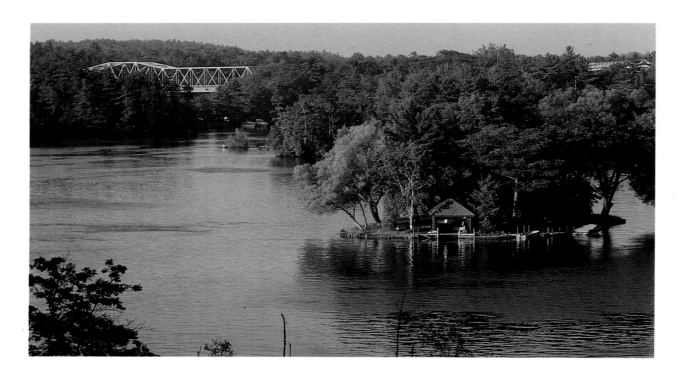

Looking from the 1,000 Islands Parkway to Surveyor Island and a section of the Ivy Lea Bridge.

In 1988 the International Bridge celebrated its 50th birthday. A parade of a thousand boats from up and down the river passed under the vast span that was originally opened on August 13, 1938, by President Franklin D. Roosevelt and Prime Minister MacKenzie King.

Flanking the whirlpools just west of the bridge is Whirlpool Island. A small bungalow on a well-kept lawn looks out over the river action. The island's retaining walls are made of perfectly fitted local stone. The owner has invested a great amount of effort in maintaining these walls, and behind the island he recently added a new lawn positioned high above the water. There is a slanting dock going right into the water, allowing its owner a unique way to land his outboard. He simply points his boat at the ramp and up he goes.

Off Ivy Lea Village the main Canadian Channel narrows between Wallace and Ash islands. The water here is swift and deep, and river traffic is heavy at times, as sailboats, cruisers, jet-skiers and windsurfers vie for channel space. Ahead, a large open expanse of water, bordered on the north by the Navy Islands and on the south by Wellesley Island, offers terrific sailing.

Red Top Island is dead ahead as the boat tour continues toward the Lake Fleet Islands, just west of the Gananoque Narrows. A charming single-storey cottage with a widow's walk and a red roof sits atop this granite island. The cottage's front veranda, high above the water, looks directly down the main channel. As the boat passes, taking care to avoid the reef, Axeman Island comes into starboard view. A cantilevered modern home, built by some of Axeman's owners from found materials, is perched on a cliff high above the water. This imaginative family has been coming to the islands for a great many years and owns a large home and boathouse on the west end of the island, which is the stage for an annual end-of-summer regatta featuring both serious and hilarious races in which everybody takes part.

Leaving the Lake Fleet Islands, the boat passes Niagara Island to port before entering a cluster of islands which include Camelot and Endymion (great yacht anchorages). The house on Niagara Island is unique to the 1,000 Islands, as it was designed in the Mediterranean style. It dominates a point of land which offers an unforgettable view to the east.

Finally the boat heads for the open waters off Howe Island and the straight return trip to Kingston. But each run up and down the river is different, and there are so many possible routes to explore. No wonder my friend never tires of his expeditions through this wonderful 1,000 Islands maze.

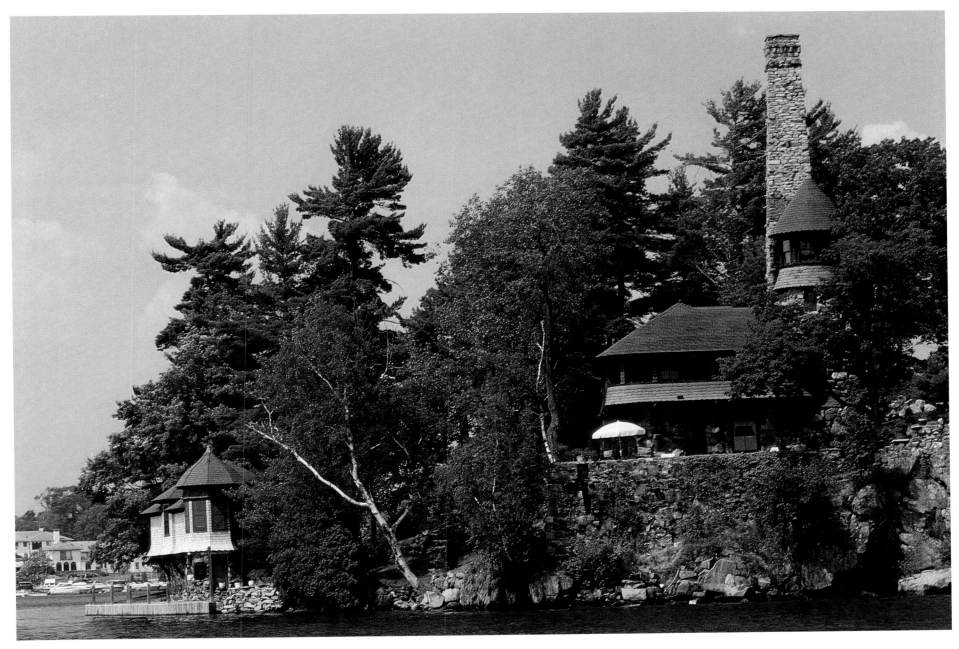

"Castle Rest" was built just across from Alexandria Bay by George M. Pullman of railway sleeping car fame. President Grant and General Sherman visited here in 1872, providing the 1,000 Islands area with some of its first major promotional exposure.

This view from Niagara Island has a definite Mediterranean flavour.

Glen House resort on the 1,000 Islands Parkway.

Two 4-H Club members at the Lansdowne Fall Fair.

The Little Blue Church near Maitland, Ontario, was rebuilt in 1845. In the cemetery is the memorial to Barbara Heck, founder of Methodism in North America. Heck settled here after the American Revolution.

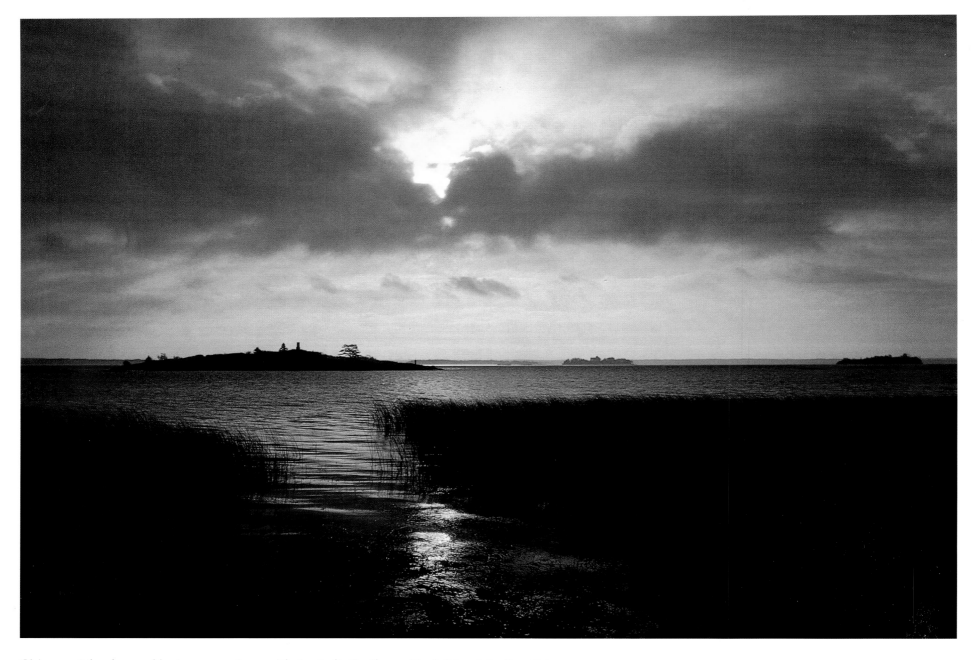

Chimney Island on a blustery morning, with Jorstadt Castle on Dark Island in the distance.